ANSEL ADAMS
CALIFORNIA

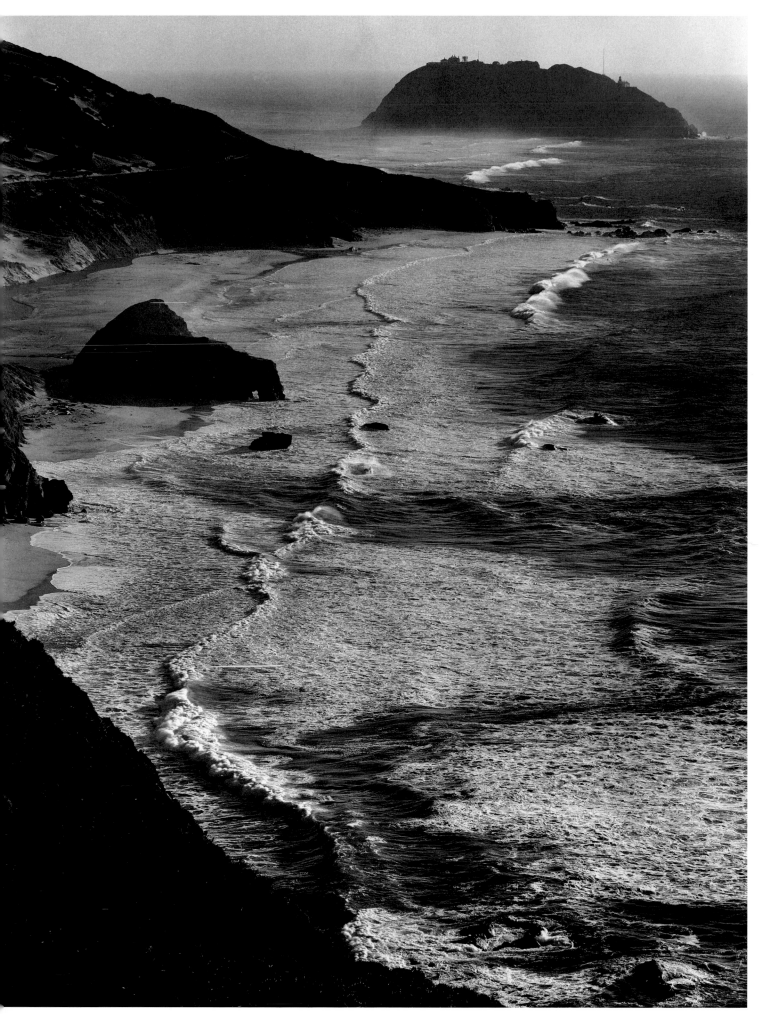

POINT SUR, STORM, BIG SUR, C. 1950

ANSEL ADAMS
CALIFORNIA

PHOTOGRAPHS BY ANSEL ADAMS

WITH CLASSIC CALIFORNIA WRITINGS

EDITED BY ANDREA G. STILLMAN

INTRODUCTION BY PAGE STEGNER

LITTLE, BROWN AND COMPANY · Boston · New York · Toronto · London

Copyright © 1997 by the Trustees of The Ansel Adams Publishing Rights Trust
Introduction © 1997 by Page Stegner
Acknowledgments of permission to reproduce and to quote from copyrighted material appear on page 111.

First Edition

Library of Congress Cataloging-in-Publication Data
Adams, Ansel, 1902–1984
California / photographs by Ansel Adams ; with classic California writings ;
edited by Andrea G. Stillman ; introduction by Page Stegner. — 1st ed.
p. cm.
ISBN 0-8212-2369-0
1. California — History — 1950– — Pictorial works. 2. California — History —
1850–1950 — Pictorial works. 3. California — History — 1950–. 4. California —
History — 1850–1950. 5. Adams, Ansel, 1902–1984. I. Stillman, Andrea
Gray. II. Title.
F862.A59 1997
979.4'05 — dc21 97-9505

Published simultaneously in Canada by
Little, Brown & Company (Canada) Limited

PRINTED IN THE UNITED STATES OF AMERICA

In May of 1971 Ansel Adams strode through the doors of the Department of Prints and Photographs at the Metropolitan Museum of Art in New York City. He was wearing a big smile, a Stetson hat, and a bolo tie, all quite unusual for the Big Apple. He had come to discuss his first major one-man retrospective in New York, and I was the staff member assigned to coordinate the show. After it opened in 1974, Ansel offered me a job as his personal assistant. I leaped at the opportunity to work for an artist of the first rank, and I was thrilled to forsake the grit of New York City for the vaunted California.

One of the first things I noticed about California was the quality of light. It seemed to me that there was something different about the light there. It was almost palpable, as if you could reach out and touch it. I remember peeking out of a tent at dawn in the High Sierra and seeing a doe and two fawns suspended in a timeless, golden light as they drank from the Lyell Fork of the Tuolumne River. And I will never forget watching with Ansel from his living room window at sunset, hoping to see his favorite "green flash." If the atmospheric elements are just right, an intense emerald green light appears for a split second precisely as the sun sinks below the edge of the dark blue Pacific.

It was light that inspired Ansel to photograph, and it was his preternatural feeling for light that made his work approach the sublime. He worked almost exclusively at dawn or sunset; the rest of the time he found the light too flat, the forms of the landscape dull and uninteresting. In an undated fragment he wrote:

"It was one of those mornings when the sunlight is burnished with a keen wind and long feathers of cloud move in a lofty sky. The silver light turned every blade of grass and every particle of sand into a luminous metallic splendor; there was nothing, however small, that did not clash in the bright wind, that did not send arrows of light through the glassy air. I was suddenly arrested in the long crunching path up the ridge by an exceedingly pointed awareness of the *light*."

Working on the selection of photographs for this book has taken me through every one of Ansel's thousands of pictures of California. Since he was a lifelong resident of the state, he photographed in almost every area in the north, driving countless miles over the course of more than sixty years. What a pleasure it was to find many rarely seen images.

Ansel often said that if you have to describe or explain a photograph it is not a successful work of art. But he liked to accompany his photographs with quotations and felt that the best combinations could forge a new, stronger whole. It was an adventure to read through hundreds of books on California, from diaries of nineteenth-century explorers to contemporary prose, in the process of selecting the writings for this book.

Whether Ansel was photographing a sand dune in Death Valley, a stand of redwoods on the North Coast, a hill near Pacheco Pass, or an old man in Merced, the subject was defined by light. It is that very special light — a California light, an Ansel light — that unifies this collection of Ansel's California photographs.

Andrea G. Stillman

ANSEL ADAMS, 1953, BY DOROTHEA LANGE

INTRODUCTION

KNOW YE THAT *on the right hand of the Indies there is an island called California, very near the Terrestrial Paradise and inhabited by black women without a single man among them and living in the manner of Amazons. . . . Their island is one of the most rugged in the world with bold rocks and crags. Their arms are all of gold, as is the harness of the wild beasts which, after taming, they ride.*

— Garci Ordóñez Rodríguez de Montalvo, 1510

THUS A SIXTEENTH-CENTURY Spanish composer of episodic novels gave the Golden State its name and origin. Montalvo's imagination was as extensive as his autograph, and although he was undoubtedly a better prophet than novelist (at least as far as the Terrestrial Paradise is concerned), it has often been suggested that his greatest contribution was to have conceived California as a myth, as a romantic apparition. Because California is as much a state of mind as it is a geophysical fact.

If the very substantive terrain that lies west of the Sierra Nevada and north of the Baja Peninsula turned out to be not quite Montalvo's land of viragoes and trained griffins, it became, in the aftermath of his popular novel, a figment of the hyperbolic imagination in many other ways. It was a land rich in treasure, a land possessing seven great cities whose streets were paved with gold, a land through the midst of which flowed a sea passage across the North American continent. It was the landscape of irrepressible dreams.

And it still is. California is the place where health, wealth, longevity, and eternal happiness are obtainable by all. California is the place one migrates to in search of the glamorous new life; the place where trees are laden with fruit, and grapes hang out into the road inspiring visions in the heads of simple folks like Beatrice Griffith and Steinbeck's Grandpa Joad. Later in this wonderful collection of Ansel Adams' images of California, in a passage accompanying an orchard in bloom in Santa Clara, Griffith recalls the symbolic representation of her own elysian fields — apricots.

". . . apricots is pennies and sometimes they are silver dollars after you pick them a long time. Now we get lots more money in the fruits cause there is a war, and now we can go to the carnival with rich money like the boss of the ranch." Grandpa Joad tells his family, "Know what I'm a-gonna do? I'm gonna pick me a wash tub full a grapes, an' I'm gonna set in 'em, an' scrooge aroun', an' let the juice run down my pants." California is El Dorado, the Garden of Eden, and the Bank of America all rolled into one.

Knowing nothing in 1510 of the new world that was about to be discovered, Montalvo located *his* mythical island somewhere in the Mediterranean Levant, and it is clearly to his readership, many of whom were the first Spanish explorers on the continent, that credit should be assigned for naming the real estate they found north of the Sea of Cortés. And it seems highly likely that in so doing these intrepid adventurers were inspired by a considerable sense of irony. As they conducted multitudinous land and sea expeditions in pursuit of myths no less fantastic than Montalvo's, they encountered a reality far harsher than any imagined to exist near the Terrestrial Paradise. No Amazons or man-eating beasts to be sure, but no gold and pearls either; no Seven Cities of Cíbola or Straits of Anian, no Golconda, no fruit bowl. Just sweat, fatigue, bickering, dysentery, scurvy, disease, starvation, thirst, and death.

During the 308 years between Juan Rodríguez Cabrillo's first sighting of San Diego Bay (1542) and President Millard Fillmore's admittance of California into the Union (1850), the territory was slowly transformed. From the relatively undisturbed hunting, gathering, and fishing grounds of native people who had inhabited the land since well before 500 B.C. (the last of whom would be virtually wiped out by the end of the nineteenth century), it became a four-hundred-mile-long coastal string of settlement — twenty-one missions, four presidios, and two pueblos, at San Jose and Los Angeles. By 1825 California would become a sovereign state within the Mexican republic, by 1846 a territorial possession of the United States, and four years later its thirty-first state.

At the time of its inclusion into the republic, California had metastasized from a collection of indigenous peoples, linguistically and tribally diverse but with similar cultural habits, to a patchwork society of Spaniards, Mexicans, white settler-soldiers, fur traders, merchants, gold seekers, Mormons, *Californios*, Chinese, Russians, Germans, Italians, and South Americans. Or as Walt Whitman describes the region in "Song of the Redwood-Tree," a portion of which is reprinted with Ansel's composition of stump and ferns in the Rockefeller Forest, Humboldt Redwoods State Park,

The fields of Nature long prepared and fallow, the silent, cyclic
 chemistry,
The slow and steady ages plodding, the unoccupied surface ripening,
 the rich ores forming beneath;
At last the New arriving, assuming, taking possession,
A swarming and busy race settling and organizing everywhere . . .

From such antecedents it is easy to understand why the left coast is still fondly regarded as the metaphoric angle of repose at which everything loose in the nation stops rolling.

My old man once observed that if you ask a Californian who he is, you are likely to get two dozen answers in two dozen languages — a sentiment expanded by Joan Didion when she asserts in *Slouching Towards Bethlehem* that "California is a place in which a boom mentality and a sense of Chekhovian loss meet in uneasy suspension." It is hardly an original insight these days to notice that the region possesses within its 158,693 square miles (an area three times the size of England) a social and geophysical landscape of such astonishing diversity that it essentially defies definition. Nevertheless, its multitudinous interpreters, as well as its native sons and daughters, go on repeating the observation ad nauseam, apparently in the hope that its echo may make them less jittery about being a part of something with no recognizable center. Bravely they go on confessing to an enduring identity crisis. (And it should be noted, parenthetically, that "they" constitute one out of every eight Americans.)

have alluded to California as a region, but it is really six or seven regions, none of which resembles any of the others in any way. A few years ago, in an article about the state's park system, I sent a group of imaginary vacationers from Vermont on a week's odyssey that began in the dense, old-growth redwood forests of Humboldt and Del Norte Counties and proceeded through the tide marshes and secluded coves of Tomales Bay, down the unimaginable sea coast of Big Sur to the expansive beaches that extend from Santa Barbara to San Diego, across the desert badlands of Anza-Borrego and Death Valley, then back north beneath the eastern face of the Sierra Nevada into Shasta County. There I abandoned them in the lava beds of the Modoc Plateau, without food and water.

Had this book been available then, I could have given my Vermonteers a grander and more authoritative tour. As it was, they got little more than a perimeter excursion. I did not expose them to the oak-studded foothills that flank either side of California's heartland, foothills that begin as grassy knolls (see Ansel's "Clearing Storm, Sonoma County Hills," or "Eroded Hills Near Pacheco Pass, Diablo Range") and rise into steep chaparral-filled canyons, thrust ever upward into the mixed conifer forests of the Coast Range Mountains and the Sierra Nevada. They saw nothing of the Central Valley from Redding to Roseville, or the thousand miles of intertwined channels, marshes, and dikes of the Sacramento River delta. They remained ignorant of the vast agricultural plain that stretches southward from Stockton to Bakersfield, an area once dominated by swamps, shallow lakes, and riparian forests of willow, sycamore, and cottonwood, now a ten-thousand-square-mile province of cotton, grapes, rice, oranges, and oil rigs. Not suitable for tourist viewing, I decided, and not enough time. Also, the experience called "summer" in the Central Valley is hardly tonic to the traveling spirit. It raises too many questions about temperature in the Garden of Eden and tends to provoke doubt. *Did we, perhaps, take a wrong turn . . .*

Besides, how does one explain the California climate to a visitor from New England? Which California? Which climate? The cold,

rain forest weather of the north coast, where in Honeydew one winter it dumped 174 inches? Or the Riviera ambience of balmy San Diego, which manages to precipitate less than an annual foot? Or the hellfire and brimstone environment of the Mojave, where in places like Needles and Barstow two inches of rain in a year can make people giddy? Or the Alpine, twenty-foot winter snowpack climate of the High Sierra? Or the cool-water coastal fogs of Monterey, San Francisco, and Marin? Mark Twain once remarked that the coldest winter he ever spent was summer in San Francisco.

If it is truly difficult for those of us who live west of the West to imagine California on any very coherent level — geologically, meteorologically, ethnologically, biotically — imagine the problem if one's point of view has been formed somewhere east of Spearfish, South Dakota. When I explain to Spearfishians that California has the seventh largest economy in the world, has all ten of the ten major soils found on the planet, has greater floral diversity than all of the central and northeast United States combined, has more national parks than any commonwealth in the Union, in fact, more than the entire country east of the Rockies, I am looked upon as a booster and a bore. When I tell New Englanders that one fine California day I climbed to the summit of 14,494-foot Mt. Whitney, the highest point in the contiguous United States, and looked sixty miles southeast over the Panamints into Death Valley, the *lowest* point on the continent (280 feet below sea level), and I tell them it was below freezing on Whitney and 130 degrees Fahrenheit at Bad Water, Death Valley, I'm excused as a fool and a liar. But what can one expect from people who call Katahdin a mountain, and think of those little hummocks over in New Hampshire as "The Presidential Range"?

Perhaps the best one can do to characterize the essence of California — which is one of the things this book implicitly attempts — is to describe it as a kaleidoscopic vision, geographically inspired and culturally perpetrated, and quickly refer those who

remain curious to the pages that follow. To be sure, California is as much people, culture, civilization (and lack of it) as it is geography, but even in a sociopolitical context the land cannot be ignored. As Mary Austin once said, "The manner of the country makes the usage of life there, and the land will not be lived in except in its own fashion."

For me this is the larger truth conveyed in *California*. The images of the state that Ansel recorded over a period of nearly four decades, elaborated by the words of writers as distinct as Austin, Jeffers, Muir, Steinbeck, W. Stegner, McPhee, and Twain (to name only a few), impress upon me, once again, not only the expansiveness of the corporeal dreamscape in which I have now lived for over half a century, but the imprint that such diversification has had on my own cultural consciousness.

There is a clarity of vision (however interwoven it may appear) that emerges from this union of pictures and text, this congress of descriptive narrations that Andrea Stillman has superbly married to the "visual music" of California's greatest photographer. Ansel has said that "photography has both a challenge and an obligation: to help us see more clearly and more deeply, and to reveal to others the grandeurs and potentials of the one and only world which we inhabit." How magnificently he met the challenge might be best reflected in Beaumont Newhall's astonished words upon coming out from under the focusing cloth of Ansel's 8x10 view camera (this reported in a letter to my father from Nancy Newhall in 1973), "Ansel, I can see better through your ground-glass than through my own eyes." It is the sort of remark that anyone browsing through this collection might well be inspired to repeat.

Page Stegner
Santa Cruz, California

ANSEL ADAMS
CALIFORNIA

W E SAILED DOWN this magnificent bay with a light wind, the tide, which was running out, carrying us at the rate of four or five knots. It was a fine day; the first of entire sunshine we had had for more than a month. We passed directly under the high cliff on which the presidio is built, and stood into the middle of the bay, from whence we could see small bays, making up into the interior, on every side; large and beautifully wooded islands, and the mouths of several small rivers.

If California ever becomes a prosperous country, this bay will be the center of its prosperity. The abundance of wood and water, the extreme fertility of its shores, the excellence of its climate, which is as near to being perfect as any in the world, and its facilities for navigation, affording the best anchoring grounds in the whole western coasts of America, all fit it for a place of great importance; and, indeed, it has attracted much attention, for the settlement of "Yerba Buena," where we lay at anchor, made chiefly by Americans and English, and which bids fair to become the most important trading place on the coast, at this time began to supply traders, Russian ships, and whalers, with their stores of wheat and frijoles.

The tide leaving us, we came to anchor near the mouth of the bay, under a high and beautifully sloping hill, upon which herds of hundreds and hundreds of red deer, and the stag, with his high branching antlers, were bounding about, looking at us for a moment, and then starting off, affrighted at the noises which we made, for the purpose of seeing the variety of their beautiful attitudes and motions.

At midnight, the tide having turned, we hove up our anchor and stood out of the bay, with a fine starry heaven about us — the first we had seen for weeks and weeks.

FROM Richard Henry Dana, Jr., *Two Years Before the Mast,* 1840

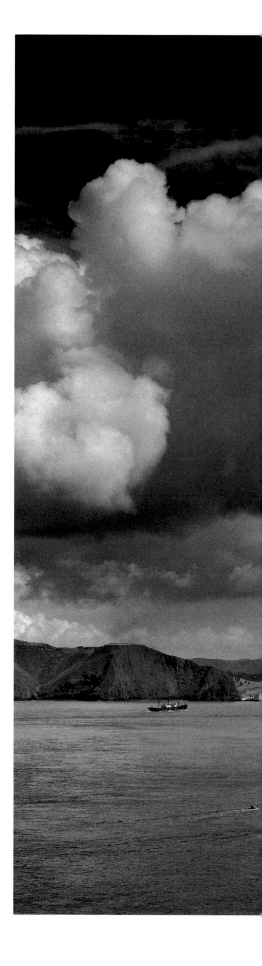

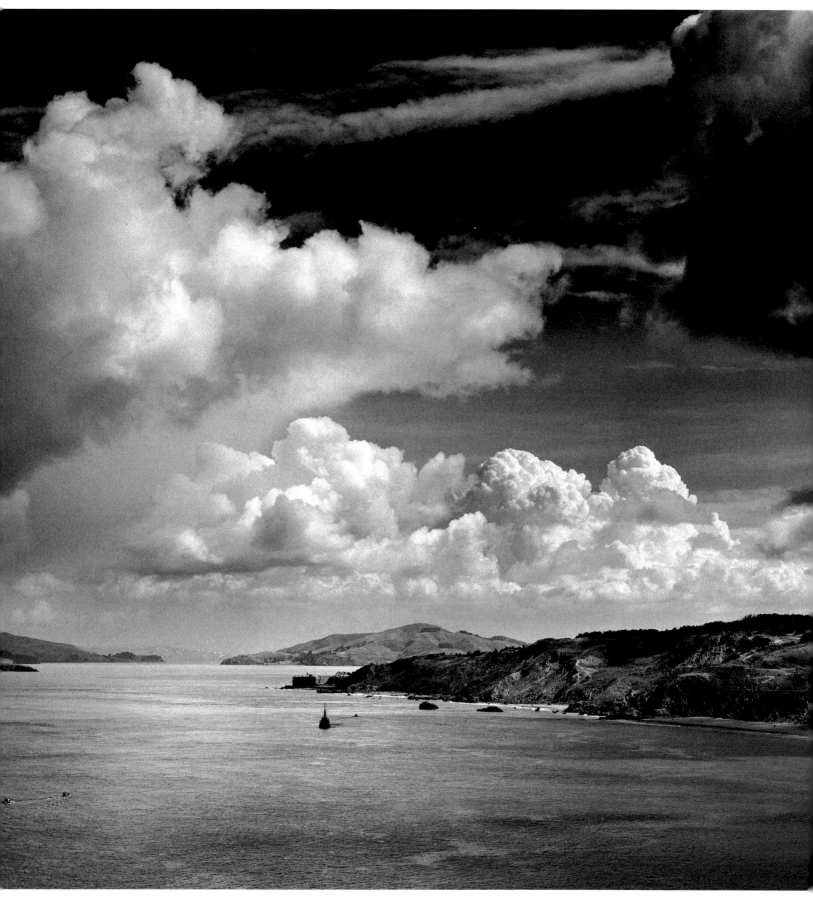

THE GOLDEN GATE BEFORE THE BRIDGE, SAN FRANCISCO, 1932

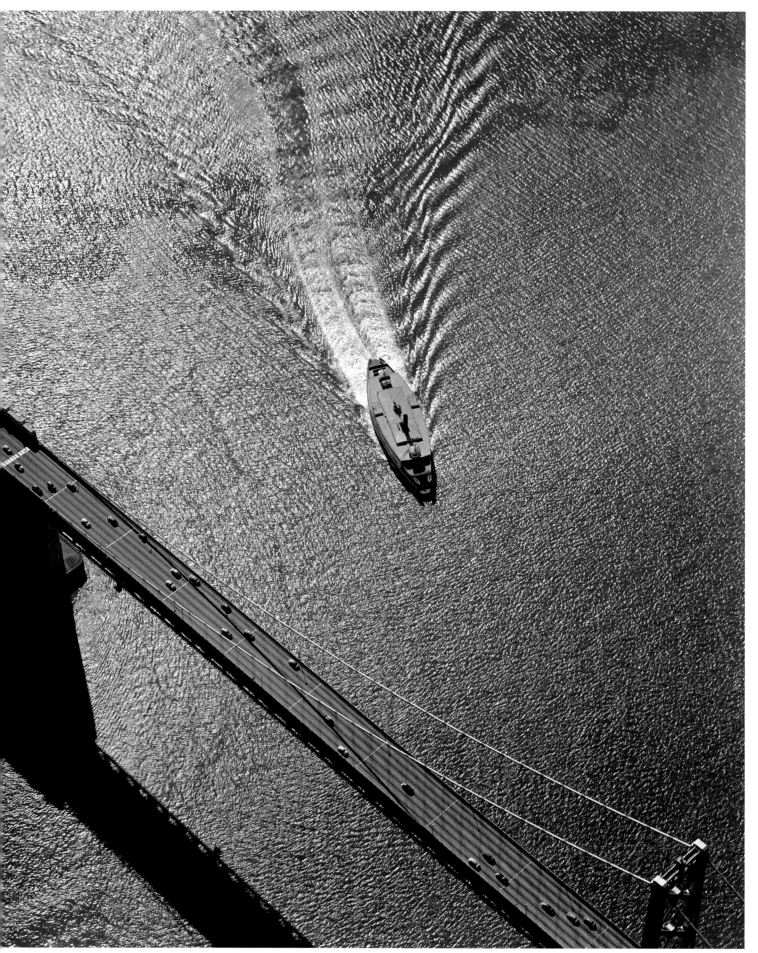

FERRY AND BAY BRIDGE FROM THE AIR, SAN FRANCISCO, 1954

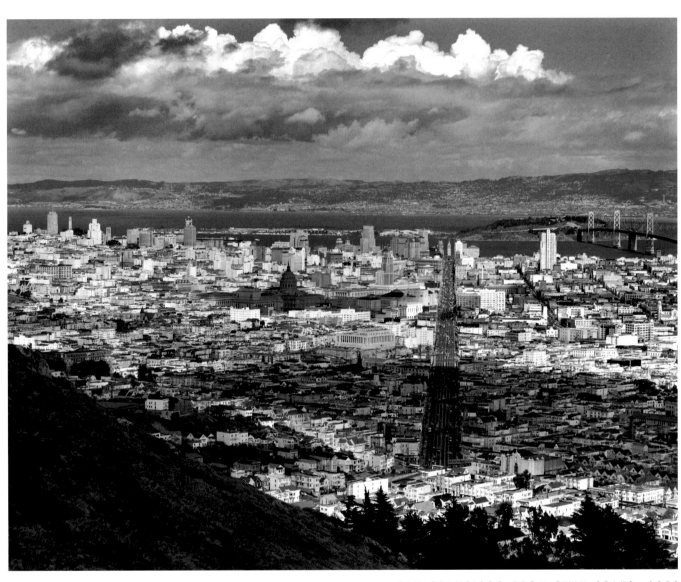

SAN FRANCISCO FROM TWIN PEAKS, 1952

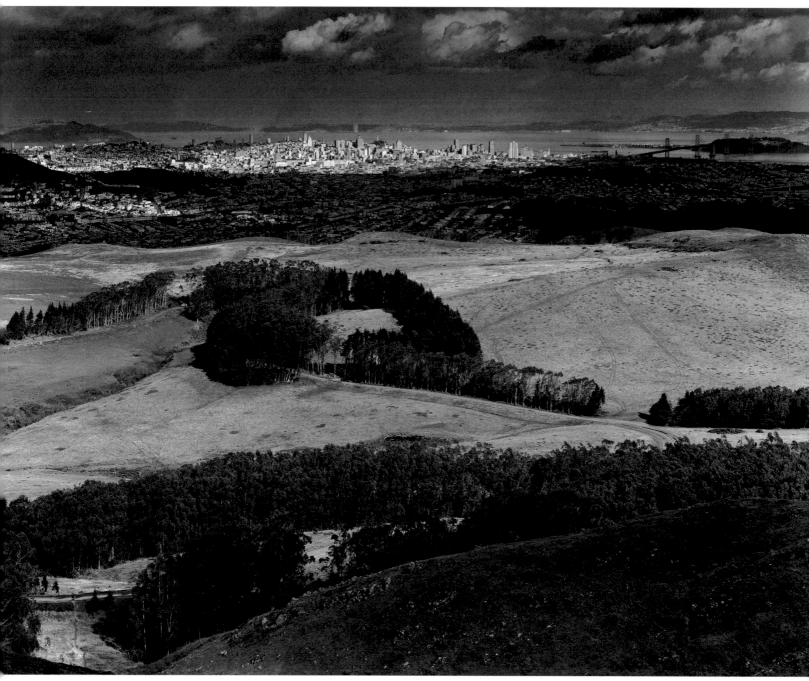

SAN FRANCISCO FROM SAN BRUNO MOUNTAIN, C. 1953

WHEN I WAS A CHILD growing up in Salinas we called San Francisco "the City." Of course it was the only city we knew, but I still think of it as the City, and so does everyone else who has ever associated with it. A strange and exclusive word is "city." Besides San Francisco, only small sections of London and Rome stay in the mind as the City. New Yorkers say they are going to town. Paris has no title but Paris. Mexico City is the Capital.

San Francisco put on a show for me. I saw her across the bay, from the great road that bypasses Sausalito and enters the Golden Gate Bridge. The afternoon sun painted her white and gold — rising on her hills like a noble city in a happy dream. A city on hills has it over flat-land places. New York makes its own hills with craning buildings, but this gold and white acropolis rising wave on wave against the blue of the Pacific sky was a stunning thing, a painted thing like a picture of a medieval Italian city which can never have existed. I stopped in a parking place to look at her and the necklace bridge over the entrance from the sea that led to her. Over the green higher hills to the south, the evening fog rolled like herds of sheep coming to cote in the golden city. I've never seen her more lovely. When I was a child and we were going to the City, I couldn't sleep for several nights before, out of bursting excitement. She leaves a mark.

FROM John Steinbeck, *Travels with Charley,* 1962

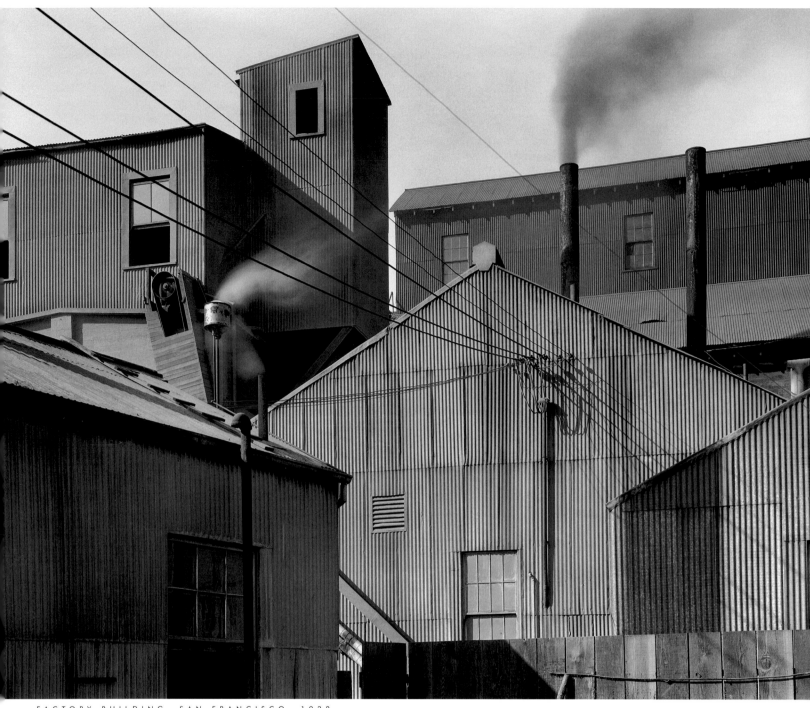

FACTORY BUILDING, SAN FRANCISCO, 1932

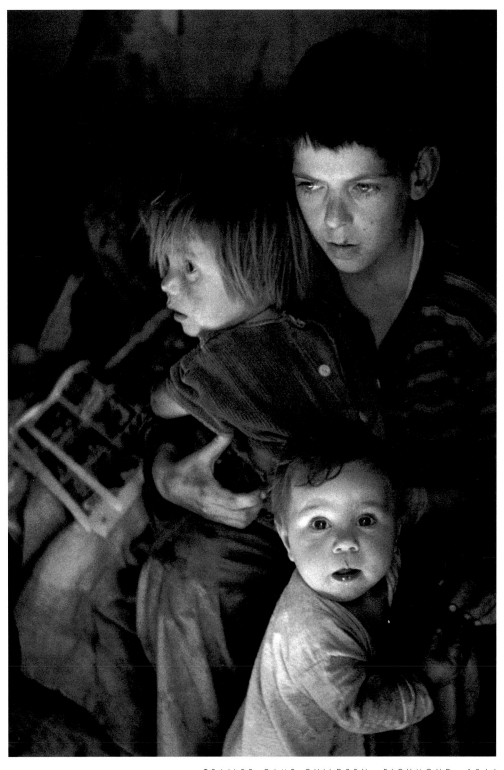

TRAILER-CAMP CHILDREN, RICHMOND, 1944

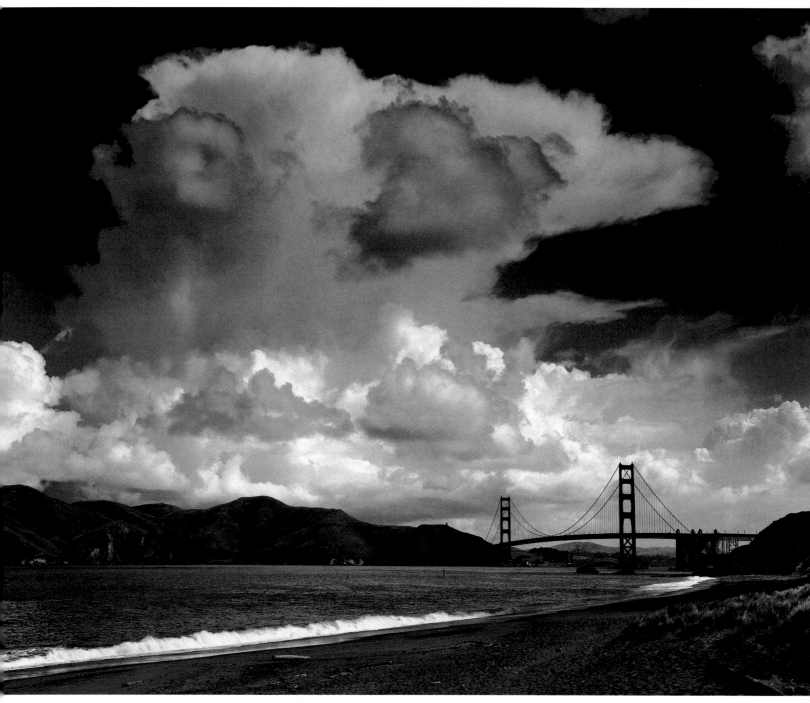

THE GOLDEN GATE AND BRIDGE FROM BAKER'S BEACH, SAN FRANCISCO, C. 1953

IT SEEMED LIKE A MATTER OF MINUTES when we began rolling in the foothills before Oakland and suddenly reached a height and saw stretched out ahead of us the fabulous white city of San Francisco on her eleven mystic hills with the blue Pacific and its advancing wall of potato-patch fog beyond, and smoke and goldenness in the late afternoon of time. "There she blows!" yelled Dean. "Wow! Made it! Just enough gas! Give me water! No more land! We can't go any further 'cause there ain't no more land! . . ."

FROM Jack Kerouac, *On the Road*, 1962

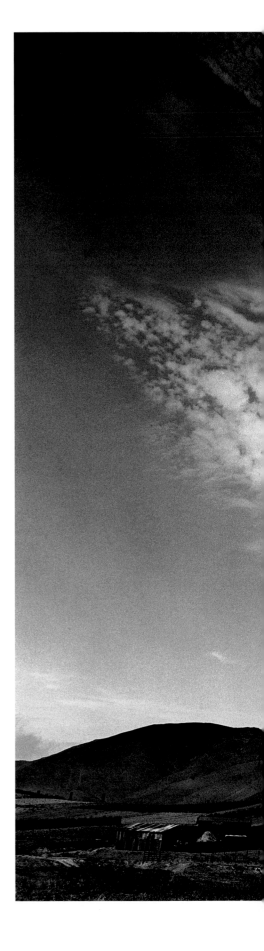

D RINKING MY COFFEE one morning in San Mateo where we were stopping with the B.'s my bed suddenly shook so that my coffee spilled. In a moment Mrs. B. rushed into my room in joyful excitement:

"Did you feel the earthquake? Wasn't it a wonderful one! I was afraid you would go back to New York and never know what they are like!"

All that day everyone we saw spoke of the earthquake in much the same way, as though some delightful happening had occurred for our special benefit. Instead of shying away from the subject they reveled in it; advised us if ever we felt a severe one to run and stand in the doorframe. Even if the whole house comes down the doorways, it seems, are perfectly safe. Then they drove us to a beautiful estate that was directly over a fault and to prove what a *real* earthquake could do, they showed us a stone wall that had been shifted four feet, and an orchard of trees that had been picked up bodily and planted elsewhere. They added casually that the house, of course, was new, the other having been quaked to the ground.

But "How *terrible*," exclaimed nearly everyone to us, "to live as you do in a country where they have *thunderstorms!*"

FROM Emily Post, *By Motor to the Golden Gate,* 1916

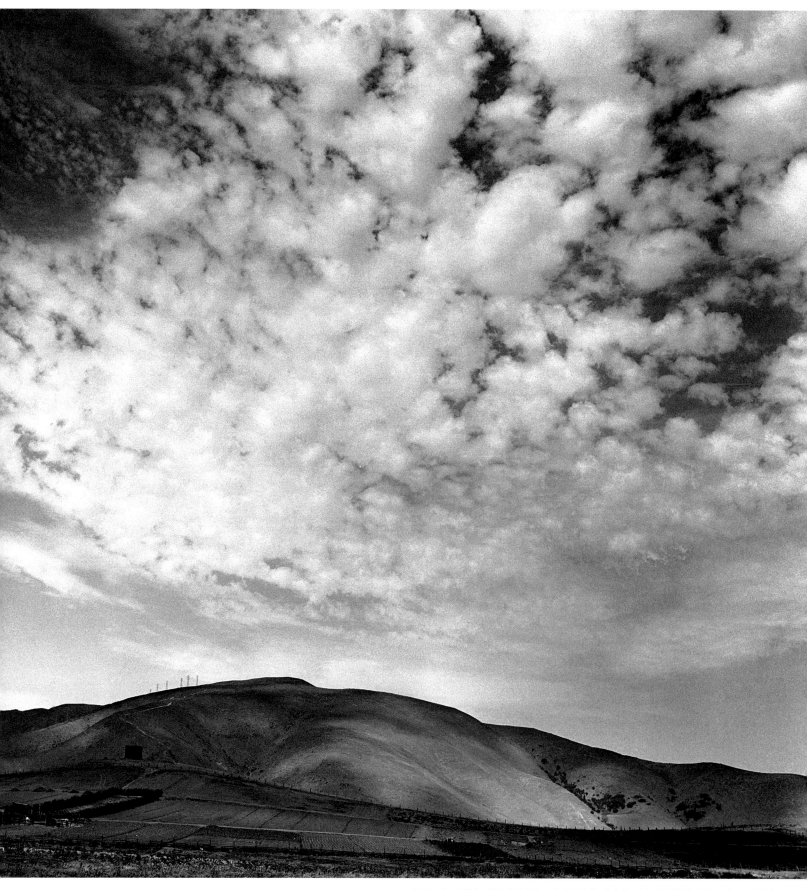

HILLS AND CLOUDS, SOUTH SAN FRANCISCO, C. 1936

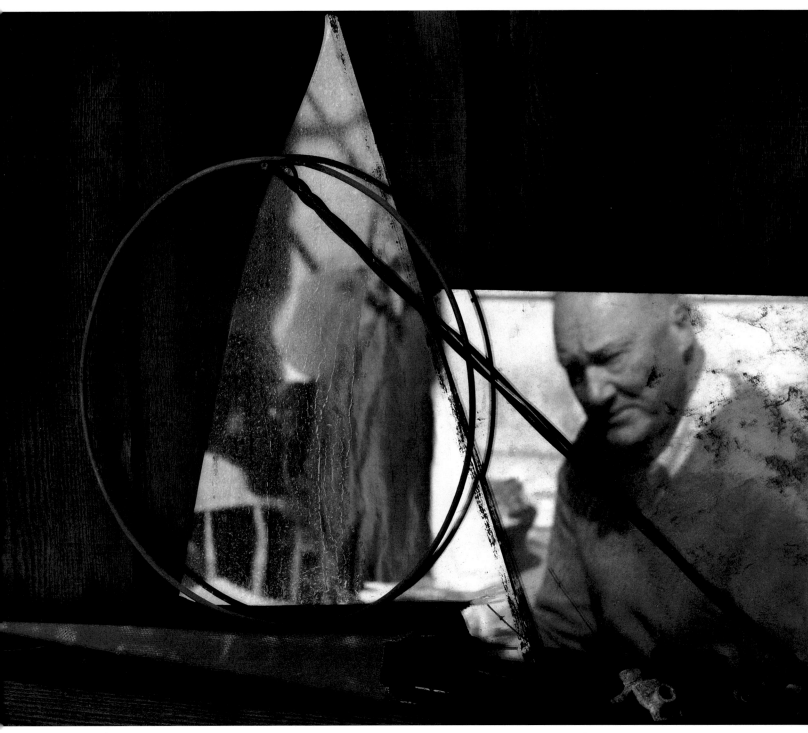

ROBERT BOARDMAN HOWARD, SAN FRANCISCO, 1961

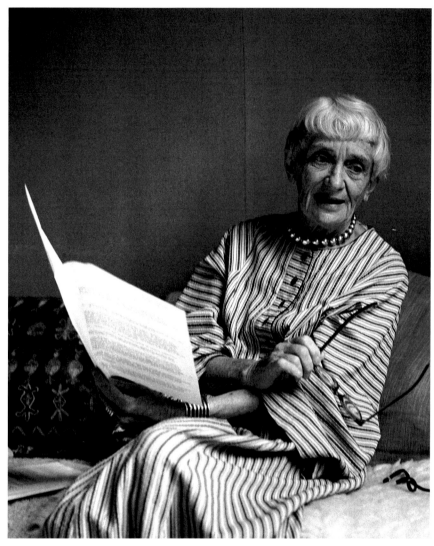

DOROTHEA LANGE, BERKELEY, 1965

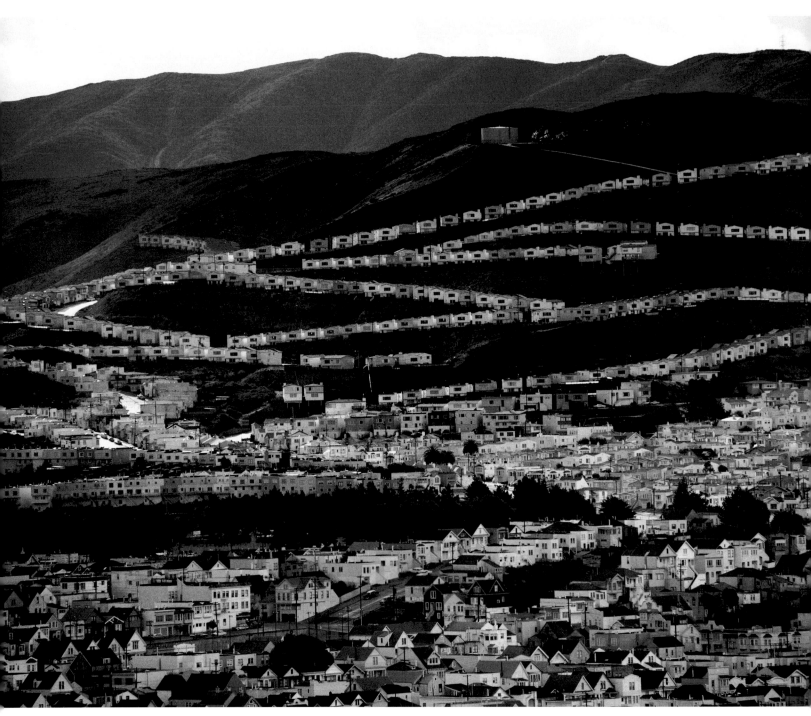

HOUSES, DALY CITY, 1966

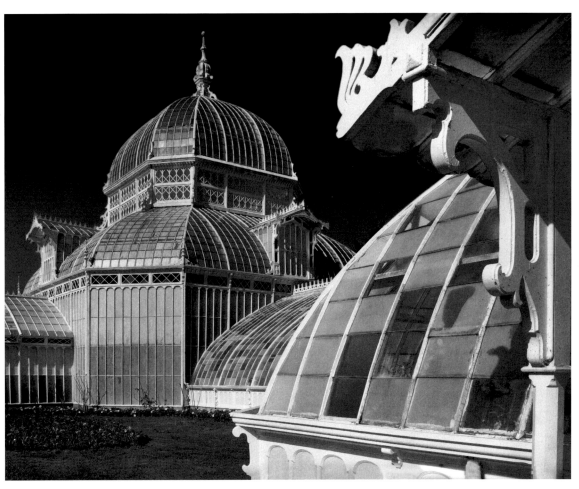

CONSERVATORY, GOLDEN GATE PARK, SAN FRANCISCO, 1962

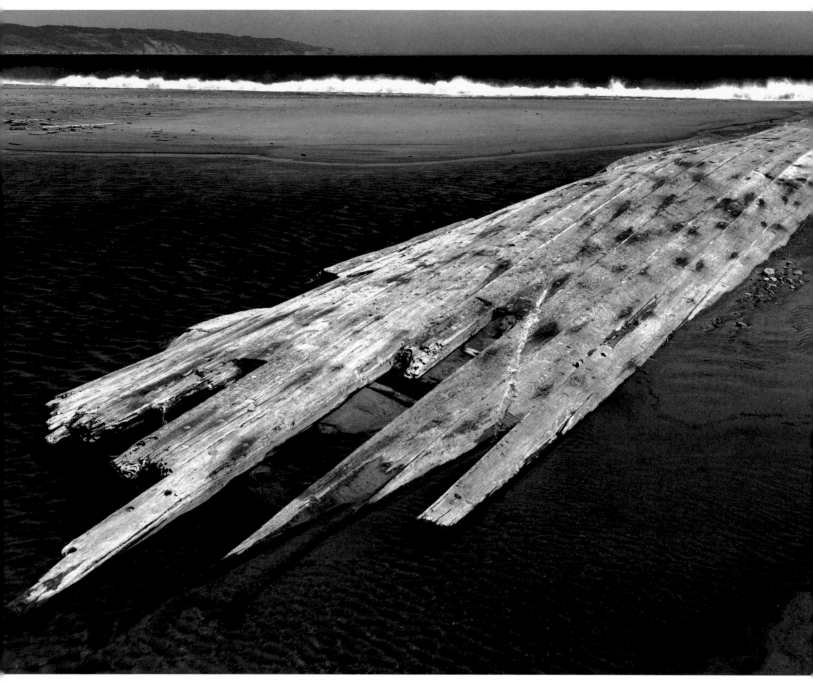

HULL OF WRECKED SHIP, BREAKERS, DRAKE'S BAY, POINT REYES NATIONAL SEASHORE, 1953

AT LAND'S END I had my first view of the Pacific Ocean. To say it is beautiful does not half express it. It is simply beyond words. The water is such a deep wonderful blue and the sound of the waves breaking on the beach and their whisper as they flow back is something to dream about. . . .

We went down on the beach where the waves were breaking. There were crowds of people there and some of them were wading. I wanted to wade. Rose said she never had but she would, so we took off our shoes and stockings and left them on the warm sand with Gillette to guard them and went out to meet the waves. A little one rolled in and covered our feet, the next one came and reached our ankles, and just as I was saying how delightful, the big one came and went above our knees. I just had time to snatch my skirts up and save them and the wave went back with a pull. We went nearer the shore and dug holes in the sand with our toes. Went out to meet the waves and ran back before the big one caught us and had such a good time.

The salt water tingled my feet and made them feel so good all the rest of the day, and just to think, the same water that bathes the shores of China and Japan came clear across the ocean and bathed my feet. In other words, I have washed my feet in the Pacific Ocean.

FROM Letter of August 29, 1915, by Laura Ingalls Wilder, *West from Home: Letters of Laura Ingalls Wilder*, 1974

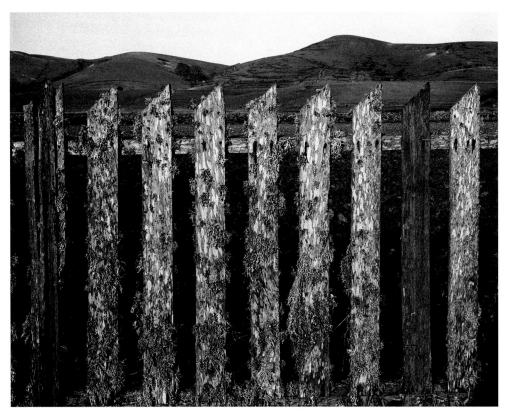

FENCE NEAR TOMALES BAY, 1936

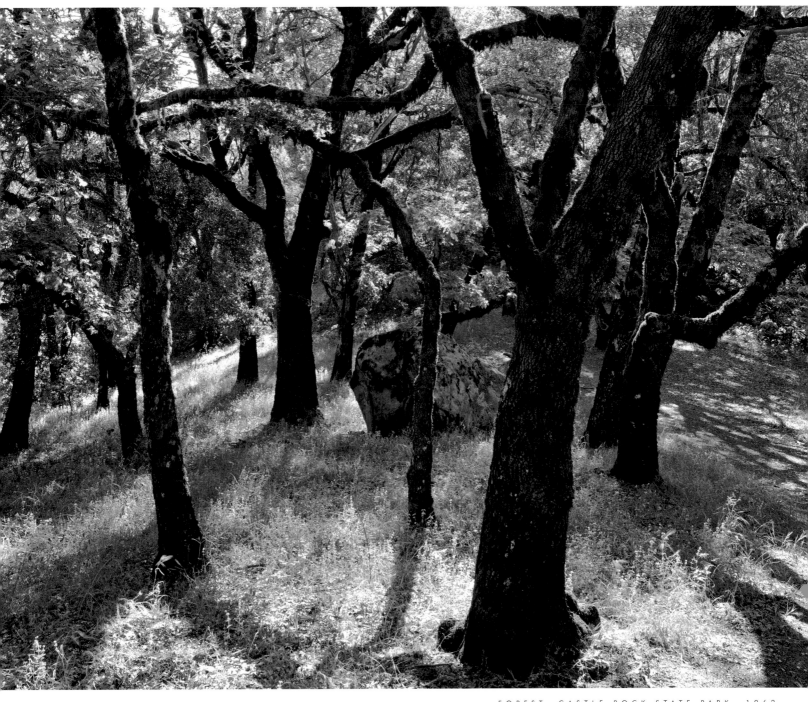

FOREST, CASTLE ROCK STATE PARK, 1962

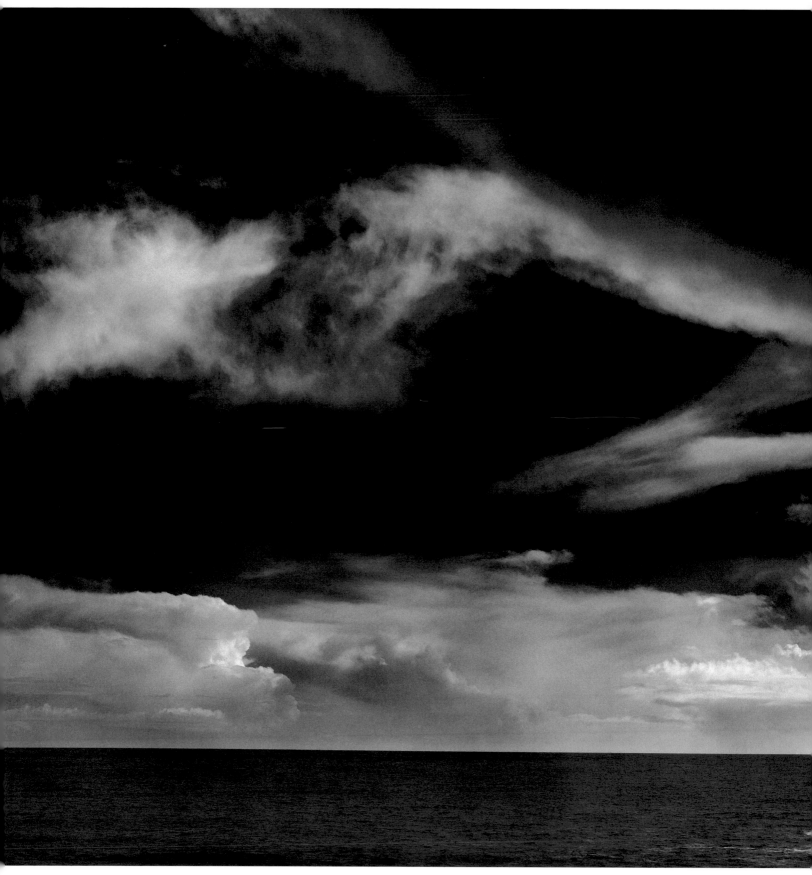

THE PACIFIC OCEAN NEAR BOLINAS, 1946

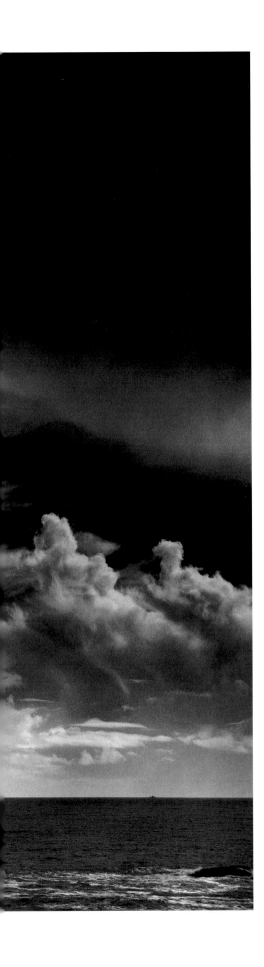

THE PACIFIC COAST through many generations was the far edge of the world for a people moving west. Balboa climbed over the mountains and found it. Magellan discovered a passage by which ships could reach it. Thereafter by land and sea men visited the western shore of the continent. Conquistador and priest, trader and pirate, rancher and miner and town-builder fashioned the rim of land into a place of legend and a lure for the adventurous. . . .

But its dwellers looked across the mountains to the lands from which they had come. Their backs were to the sea. The ocean behind them seemed at best but an avenue by which ships could bring them news and supplies from the East. The sea was an empty room in the dwelling place of mankind — a vacant space setting them apart from an ancient and disregarded world. . . .

The Pacific Coast frontiersmen were engrossed with their own task — the conquest and development of their continent. But the time came when the struggle for the possession of the West was finished. . . . Culture was finding its home among them. Less often did they look back toward the East. They glanced over their shoulders and saw Hawaii. They turned about and there was an awakened Japan, a China with its eternal problems, a Russia on the sea at the end of a transcontinental march like their own. The Pacific was no longer an empty room, a vacant space setting them apart from the Old East. It introduced them to a strange world. They had settled and tamed a land. Now they found themselves in the open doorway of a new life.

As America had been coming into equality with Europe, so was the Pacific coming into an equality with the Atlantic. The Atlantic brought an old world in touch with a new. The Pacific brought a new world in touch with an old. California and China, Oregon and Hawaii, Mexico and the Philippines, Peru and Australia made each other's acquaintance. They came to see that instead of a dividing factor, a river or an ocean is bound to become a unifying force. The Basin of the Pacific was an entity. Its history was a unity. A community of interest and experience bound together the peoples that looked out upon the great ocean.

FROM John Carl Parish, editorial for the first issue of the *Pacific Historical Review,* 1932

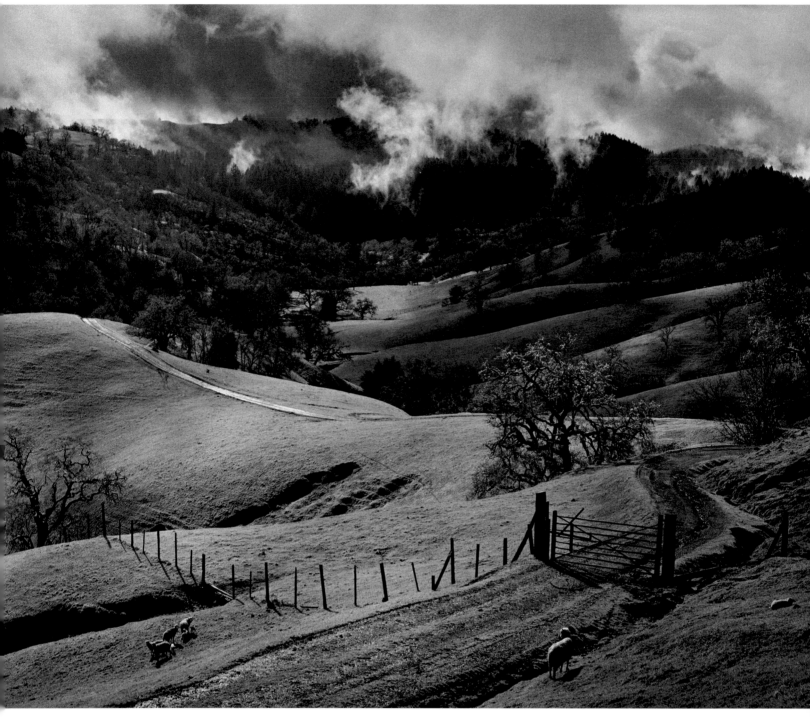

PASTURE, SONOMA COUNTY, 1951

ONE SUNDAY MORNING, about five, the first brightness called me. I rose and turned to the east, not for my devotions, but for air. The night had been very still. . . . But I had no sooner reached the window than I forgot all else in the sight that met my eyes, and I made but two bounds into my clothes, and down the crazy plank to the platform.

The sun was still concealed below the opposite hilltops, though it was shining already, not twenty feet above my head, on our mountain slope. But the scene, beyond a few near features, was entirely changed. Napa valley was gone; gone were all the lower slopes and woody foothills of the range; and in their place, not a thousand feet below me, rolled a great level ocean. It was as though I had gone to bed the night before, safe in a nook of inland mountains, and had awakened in a bay upon the coast. . . . Far away were hilltops like little islands. Nearer, a smoky surf beat about the foot of precipices and poured into all the coves of these rough mountains. . . .

. . . I began to observe that this sea was not so level as at first sight it appeared to be. Away in the extreme south, a little hill of fog arose against the sky above the general surface, and as it had already caught the sun, it shone on the horizon like the topsails of some giant ship. There were huge waves, stationary, as it seemed, like waves in a frozen sea; and yet, as I looked again, I was not sure but they were moving after all, with a slow and august advance. And while I was yet doubting, a promontory of the hills some four or five miles away, conspicuous by a bouquet of tall pines, was in a single instant overtaken and swallowed up. It reappeared in a little, with its pines, but this time as an islet, and only to be swallowed up once more and then for good. This set me looking nearer, and I saw that in every cove along the line of mountains the fog was being piled in higher and higher, as though by some wind that was inaudible to me. I could trace its progress, one pine tree first growing hazy and then disappearing after another; although sometimes there was none of this forerunning haze, but the whole opaque white ocean gave a start and swallowed a piece of mountain at a gulp. It was to flee these poisonous fogs that I had left the seaboard, and climbed so high among the mountains. And now, behold, here came the fog to besiege me in my chosen altitudes, and yet came so beautifully that my first thought was of welcome.

FROM Robert Louis Stevenson, "The Sea Fogs," *Silverado Squatters*, 1884

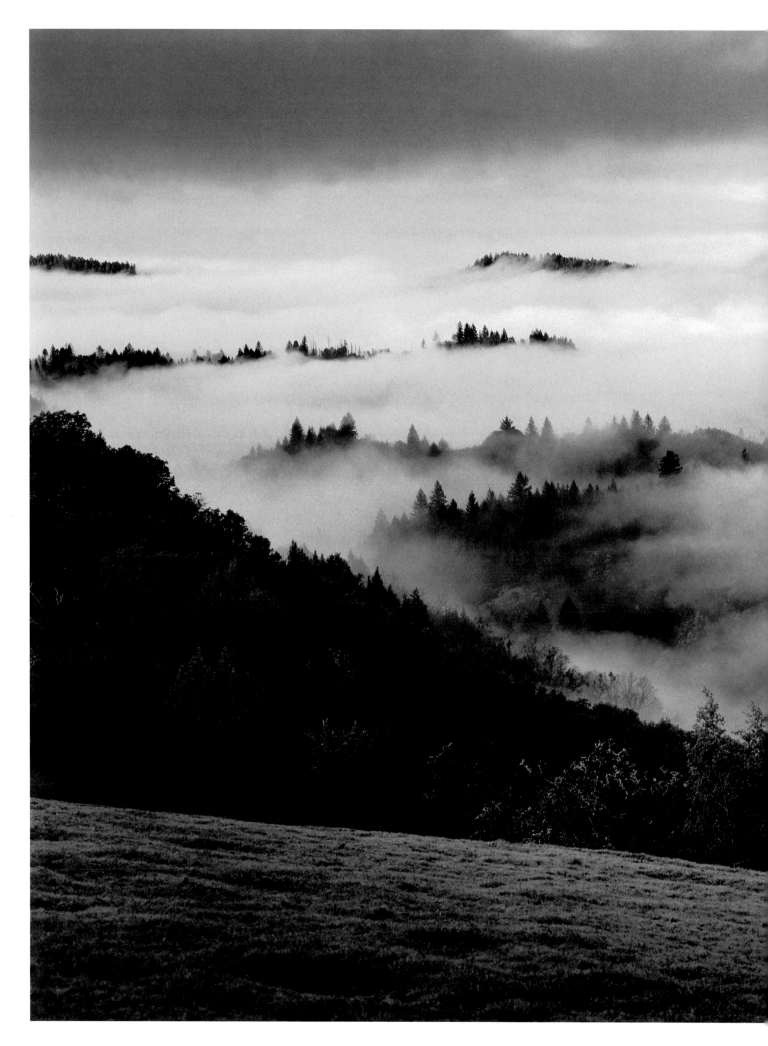

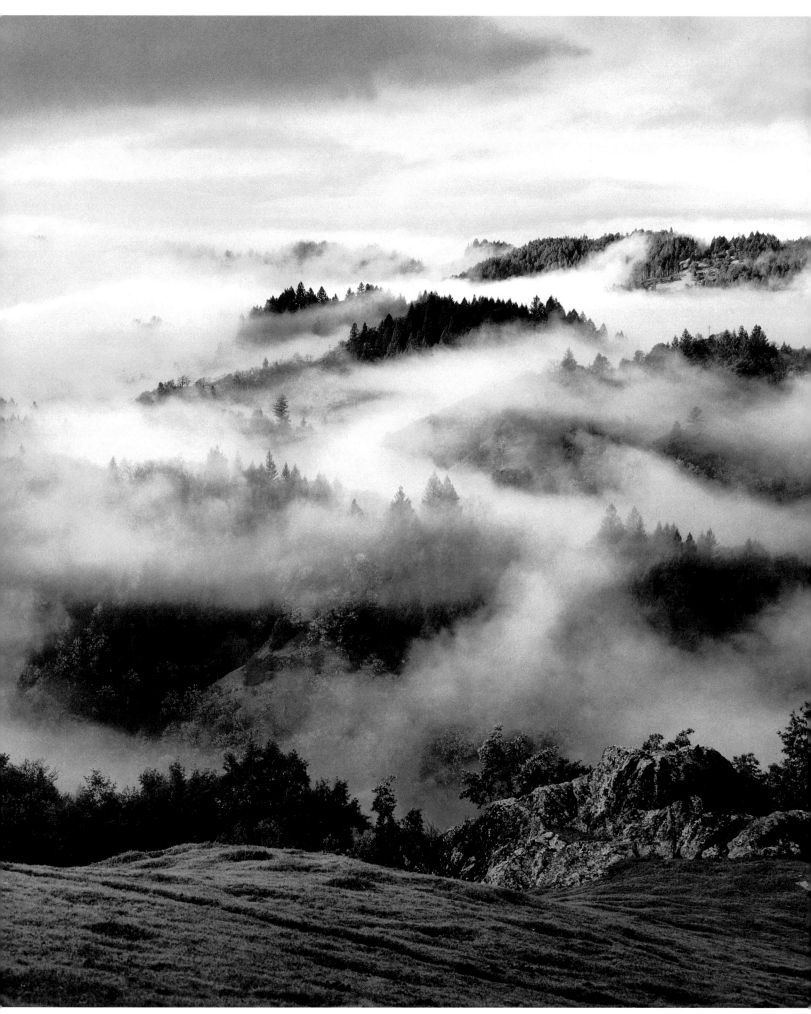

CLEARING STORM, SONOMA COUNTY HILLS, 1951

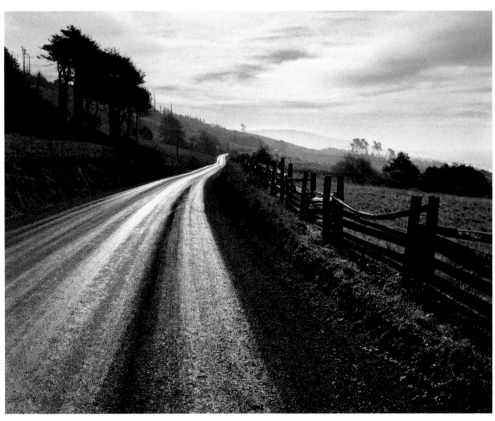

ROAD AFTER RAIN, NORTH COAST, 1959

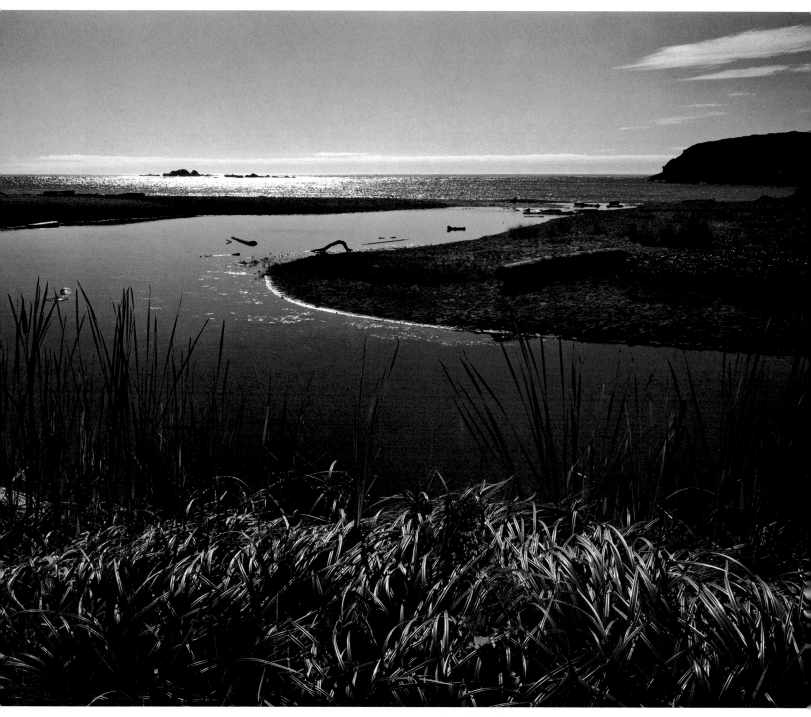

GRASS, REEDS, WATER, NEAR LITTLE RIVER, 1959

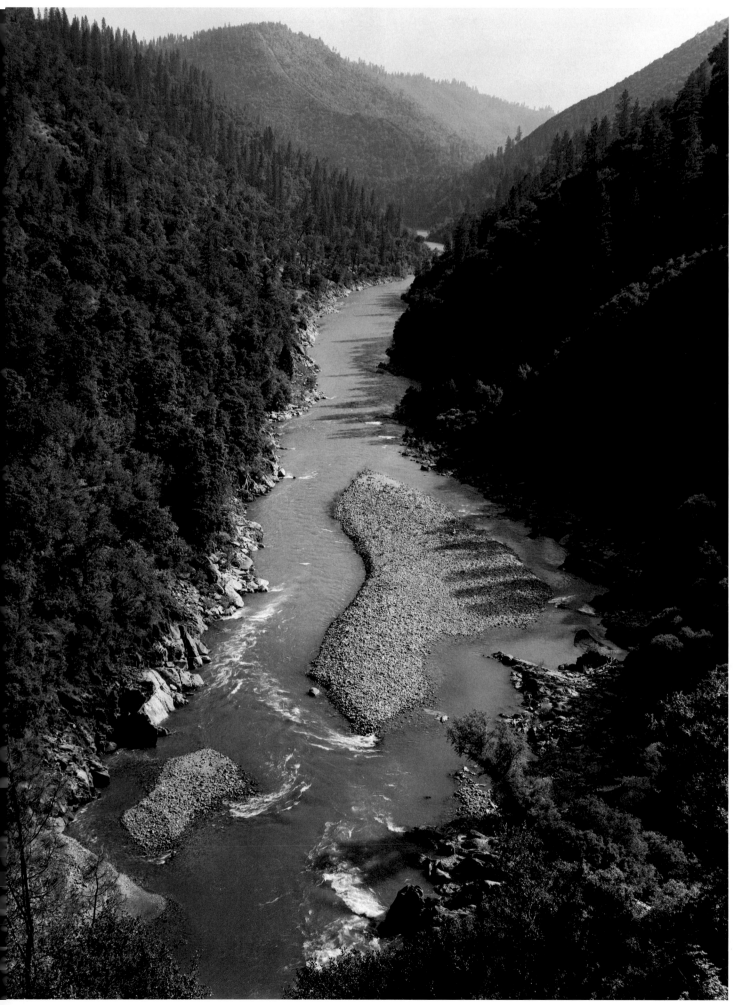

GRAVEL BARS, AMERICAN RIVER, SHIRT TAIL CANYON ROAD, 1953

A FINE MESS! . . . I sit here alone and cannot find the others. However, the river is right in front of me, and I hope to find them tomorrow. The eternal going up and down hill is so exhausting that I'd rather camp here by the water at a good fire and suffer a little hunger than to continue to run around in these rocks and mountains. If the weather just stays this way, and the ring around the moon has been there only to scare me, I won't worry!

MARCH 3, 1843

This is beginning to get serious. I couldn't find the others again, and I am alone here, about twelve miles down the river. They must have taken another route, and I have to look out for myself now. My only salvation is to travel in the direction of the valley. The valley of the Feather River [really the American River], which I am in now, seems to widen and thus make it possible to travel along the river. An Indian trail leads out of it; perhaps I can find some Indians from whom I can get something to eat. Since yesterday morning I have not eaten a thing except a few sweet onions which I just scratched out of the ground. At the same time, I found an ants' nest, a portion of which I bit off and swallowed. Nor do I have any tobacco. How will this end?

MARCH 4, 1843

Today I made about seven or eight miles. I am moving now according to a definite, life-saving plan. I must go on toward the Sacramento Valley, but slowly. To be able to walk at all with this nourishment, I start early in the morning, as soon as the sun is out, move very slowly, along the water if possible, and take frequent rests. I dig up a few onions, a hard job because

I have only a pocket knife and they are deep between the rocks. At two or three o'clock I search for a spot where I can find fungus or enough wood to have a fire for the night. I have no axe to cut wood, nor would I have enough strength. . . . Just now I have scraped up my evening meal. On the way I came across small puddles where I caught a few frogs. I pulled off their legs and chewed them. Everything will be all right if I only keep a stiff upper lip.

MARCH 21, 1843

Life is as checkered as a Scotch plaid. On the fifth of March I started as described above. After a walk of two hours I suddenly came upon our mule tracks, which I naturally followed, although I had no hope whatsoever of meeting the party before reaching the settlements. Soon afterwards I came to an Indian hut, in front of which about six natives were sitting. I walked straight up to them, sat down among them, and gave them to understand that I was hungry. They immediately served me acorns, some of which I ate, and others I put in my pocket. When they saw this, they themselves filled both my pockets to capacity. I took my leave and was very much relieved that my pockets were filled; this would surely bring me into the valley. At two o'clock I came to a fire at which my party had their noon meal. Now or never, I thought. They could not make a long journey with such animals. I collected my last ounce of strength, and before sunset I saw the lodge before me. Friends — beautiful grass — magnificent country.

FROM Charles Preuss, *Exploring with Frémont*

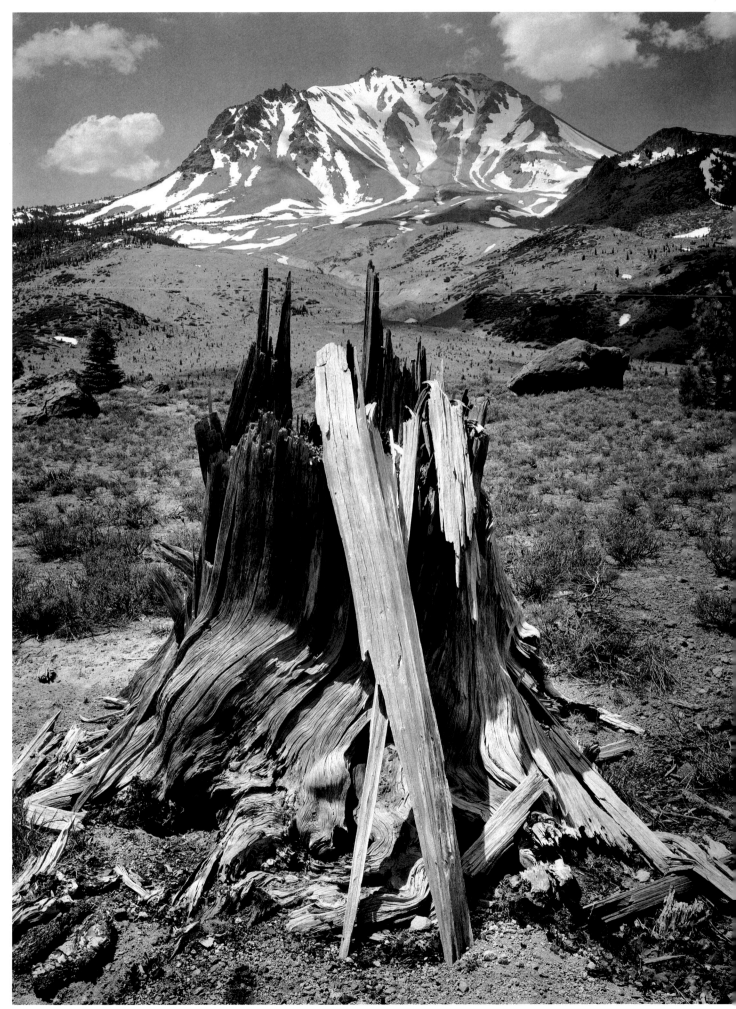

MOUNT LASSEN FROM THE DEVASTATED AREA, MOUNT LASSEN VOLCANIC NATIONAL PARK, 1949

SONG OF THE REDWOOD-TREE

A California song,
A prophecy and indirection, a thought
 impalpable to breathe as air,
A chorus of dryads, fading, departing, or hamadryads departing,
A murmuring, fateful, giant voice, out of the earth and sky,
Voice of a mighty dying tree in the redwood forest dense.

Farewell my brethren,
Farewell O earth and sky, farewell ye neighboring waters,
My time has ended, my term has come.

Along the northern coast,
Just back from the rock-bound shore and the caves,
In the saline air from the sea in the Mendocino country,
With the surge for base and accompaniment low and hoarse,
With crackling blows of axes sounding musically driven by
 strong arms,
Riven deep by the sharp tongues of the axes, there in the
 redwood forest dense,
I heard the mighty tree its death-chant chanting. . . .

Murmuring out of its myriad leaves,
Down from its lofty top rising two hundred feet high,
Out of its stalwart trunk and limbs, out of its foot-thick bark,
That chant of the seasons and time, chant not of the past only
 but the future. . . .

The flashing and golden pageant of California,
The sudden and gorgeous drama, the sunny and ample lands,
The long and varied stretch from Puget sound to Colorado south,
Lands bathed in sweeter, rarer, healthier air, valleys and
 mountain cliffs,

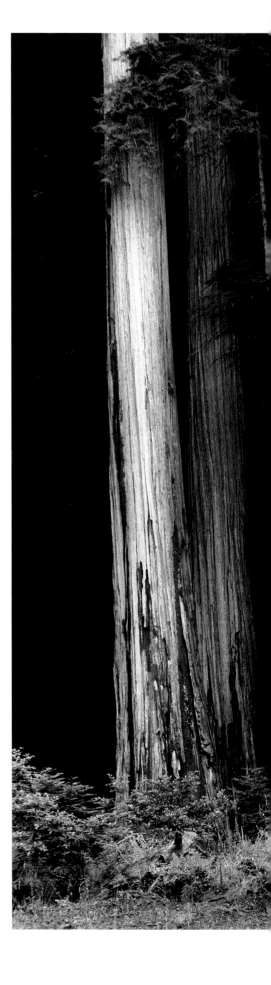

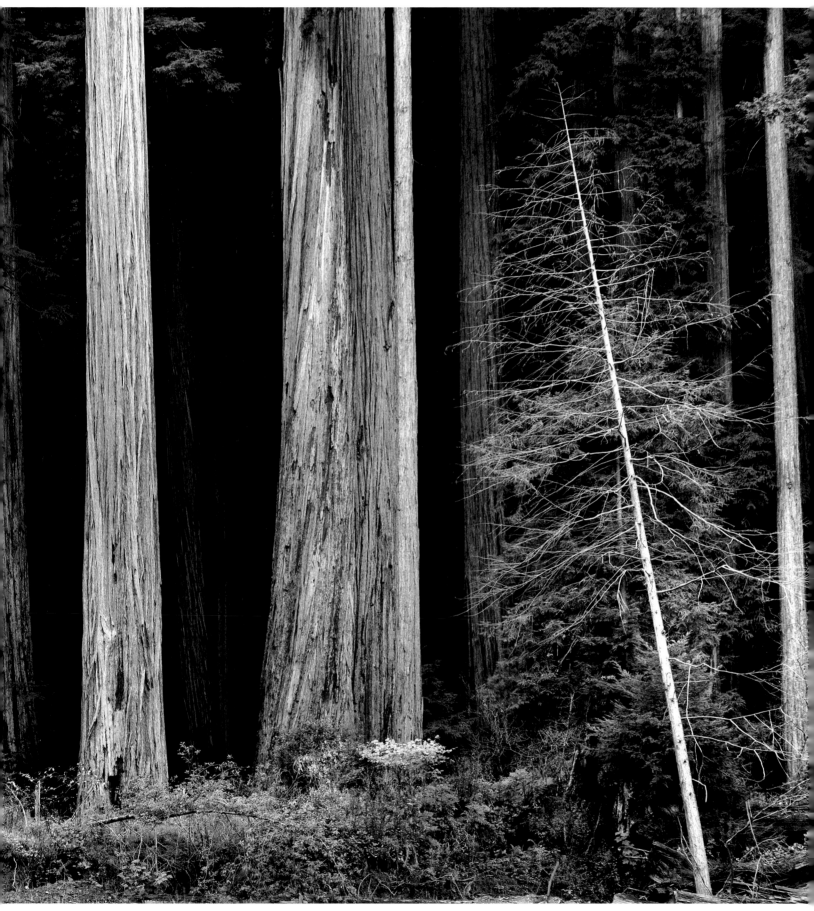

REDWOODS, BULL CREEK FLAT, C. 1960

The fields of Nature long prepared and fallow, the silent,
 cyclic chemistry,
The slow and steady ages plodding, the unoccupied surface
 ripening, the rich ores forming beneath;
At last the New arriving, assuming, taking possession,
A swarming and busy race settling and organizing everywhere,
Ships coming in from the whole round world, and going out to
 the whole world,
To India and China and Australia and the thousand island
 paradises of the Pacific,
Populous cities, the latest inventions, the steamers on the rivers,
 the railroads, with many a thrifty farm, with machinery,
And wool and wheat and the grape, and diggings of yellow gold.

But more in you than these, lands of the Western shore,
(These but the means, the implements, the standing-ground,)
I see in you, certain to come, the promise of thousands of
 years, till now deferr'd,
Promis'd to be fulfill'd, our common kind, the race.

The new society at last, proportionate to Nature,
In man of you, more than your mountain peaks or stalwart
 trees imperial,
In woman more, far more, than all your gold or vines, or even
 vital air.

Fresh come, to a new world, indeed, yet long prepared,
I see the genius of the modern, child of the real and ideal,
Clearing the ground for broad humanity, the true America,
 heir of the past so grand,
To build a grander future.

FROM Walt Whitman, "Song of the Redwood-Tree,"
Leaves of Grass, 1882

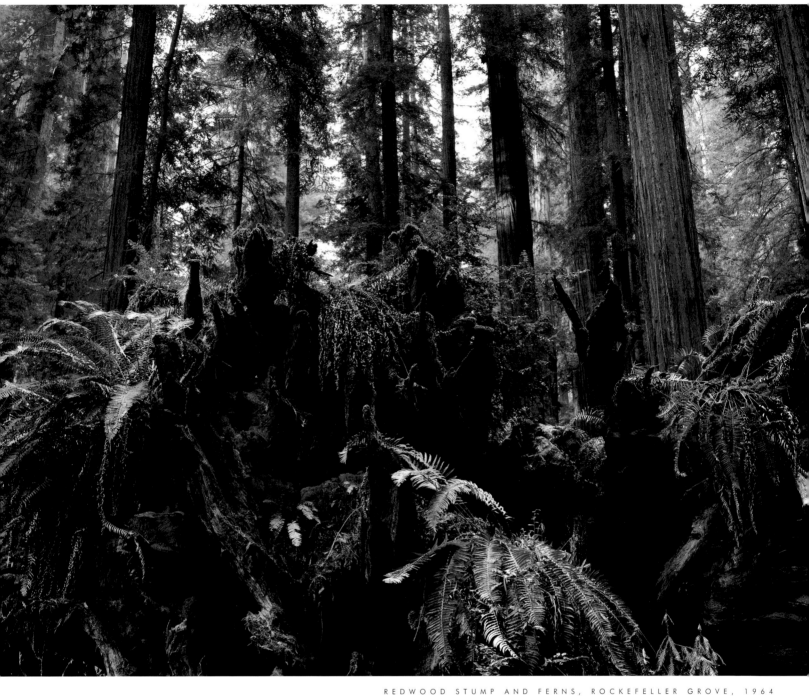

REDWOOD STUMP AND FERNS, ROCKEFELLER GROVE, 1964

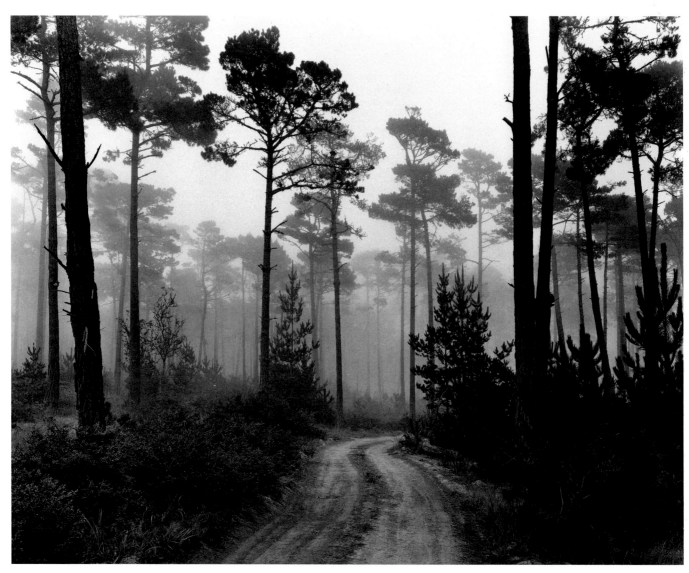

ROAD AND FOG, DEL MONTE FOREST, PEBBLE BEACH, 1964

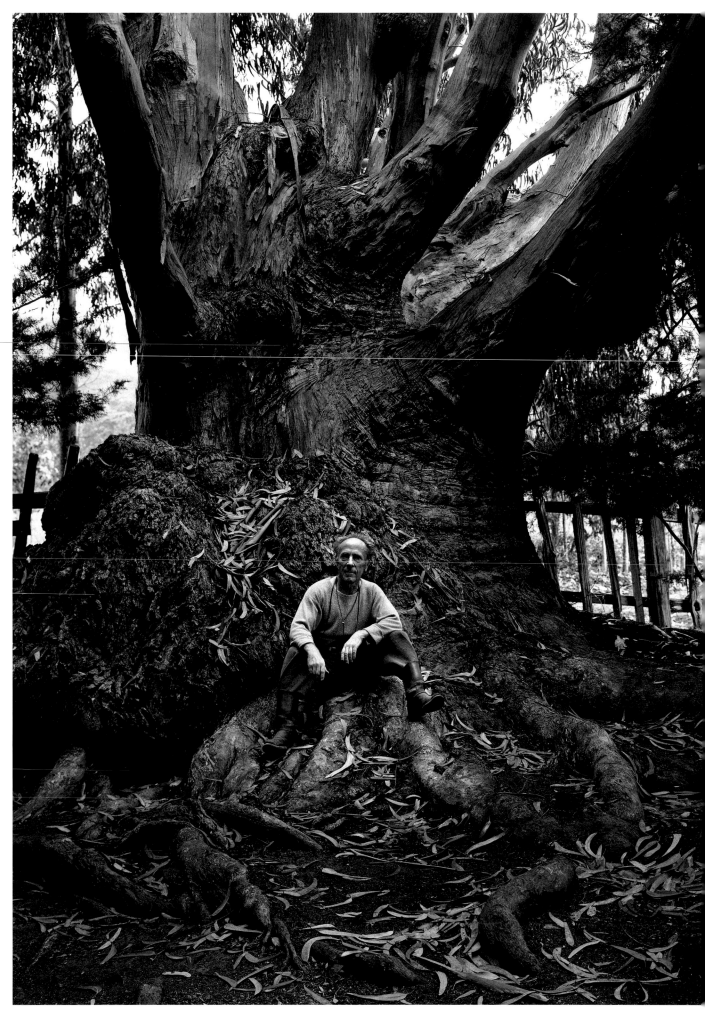

EDWARD WESTON, CARMEL HIGHLANDS, 1945

NOW AND THEN a visitor will remark that there is a resemblance between this coast, the South Coast, and certain sections of the Mediterranean littoral; others liken it to the coast of Scotland. But comparisons are vain. Big Sur has a climate of its own and a character all its own. It is a region where extremes meet, a region where one is always conscious of weather, of space, of grandeur, and of eloquent silence. . . .

From our perch, which is about a thousand feet above the sea, one can look up and down the coast a distance of twenty miles in either direction. The highway zigzags like the Grande Corniche. Unlike the Riviera, however, here there are but few houses to be seen. The old-timers, those with huge landholdings, are not eager to see the country opened up. They are all for preserving its virginal aspect. How long will it hold out against the invader? That is the big question. . . .

Often, when following the trail which meanders over the hills, I pull myself up in an effort to encompass the glory and the grandeur which envelops the whole horizon. Often, when the clouds pile up in the north and the sea is churned with white caps, I say to myself: "This is the California that men dreamed of years ago, this is the Pacific that Balboa looked out on from the Peak of Darien, this is the face of the earth as the Creator intended it to look."

FROM Henry Miller, "Topographical," *Big Sur and the Oranges of Hieronymus Bosch*, 1957

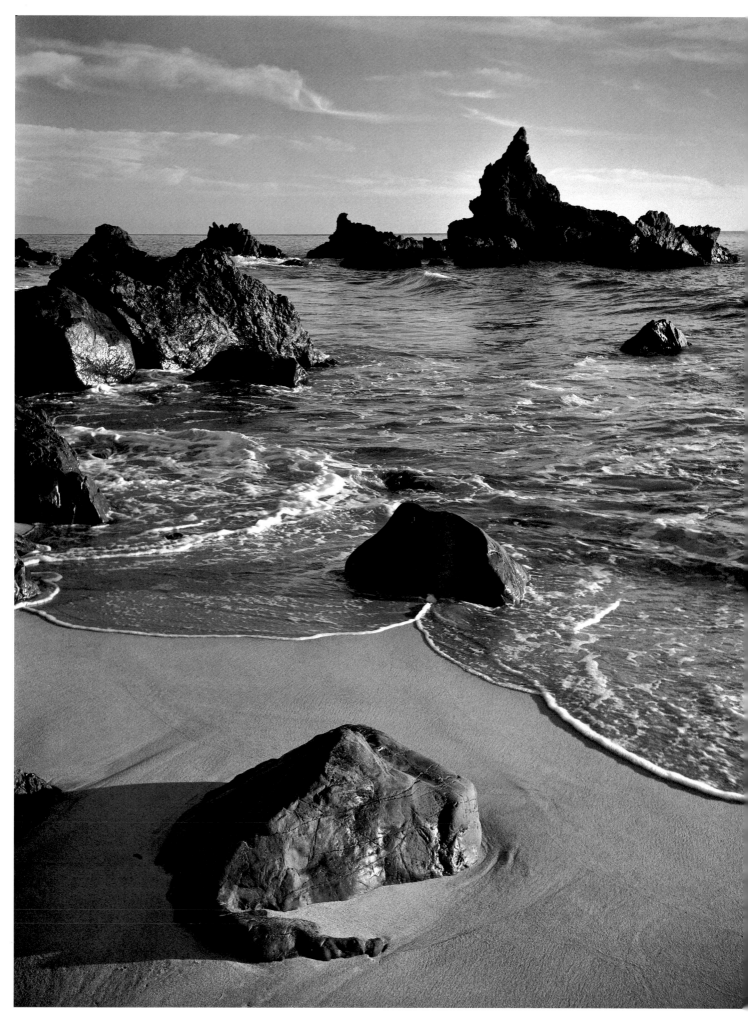

SURF AND ROCK, MONTEREY COUNTY COAST, C. 1945

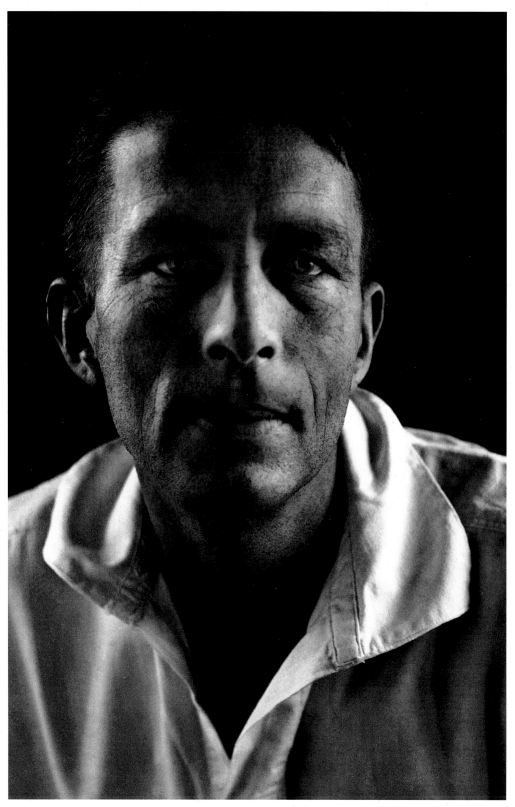

ROBINSON JEFFERS, CARMEL, 1927

"RETURN"

A little too abstract, a little too wise,
It is time for us to kiss the earth again,
It is time to let the leaves rain from the skies,
Let the rich life run to the roots again.
I will go down to the lovely Sur Rivers
And dip my arms in them up to the shoulders.
I will find my accounting where the alder leaf quivers
In the ocean wind over the river boulders.
I will touch things and things and no more thoughts,
That breed like mouthless May-flies darkening the sky,
The insect clouds that blind our passionate hawks
So that they cannot strike, hardly can fly.
Things are the hawk's food and noble is the mountain, Oh noble
Pico Blanco, steep sea-wave of marble.

FROM Robinson Jeffers, *Solstice and Other Poems*, 1935

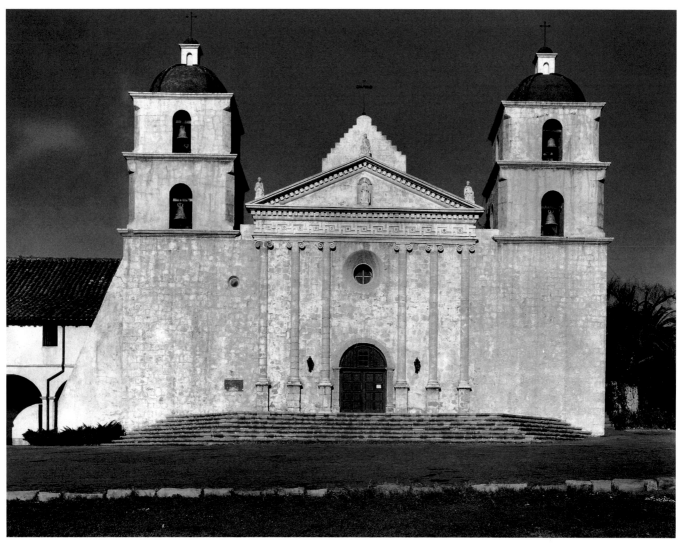

MISSION, SANTA BARBARA, 1946

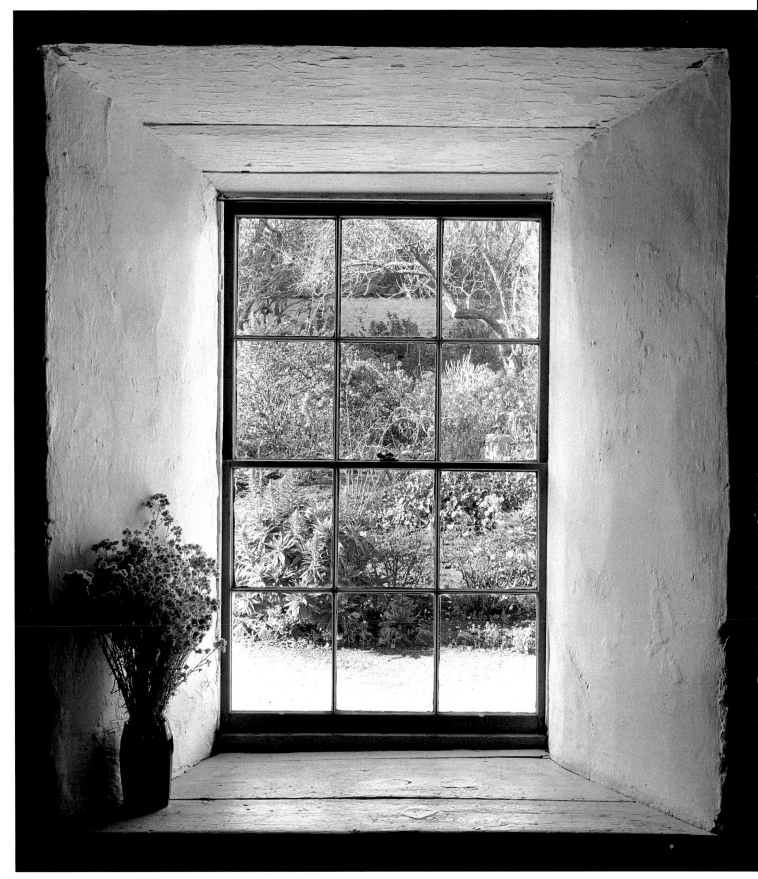

WINDOW, ROBERT LOUIS STEVENSON HOUSE, MONTEREY, 1953

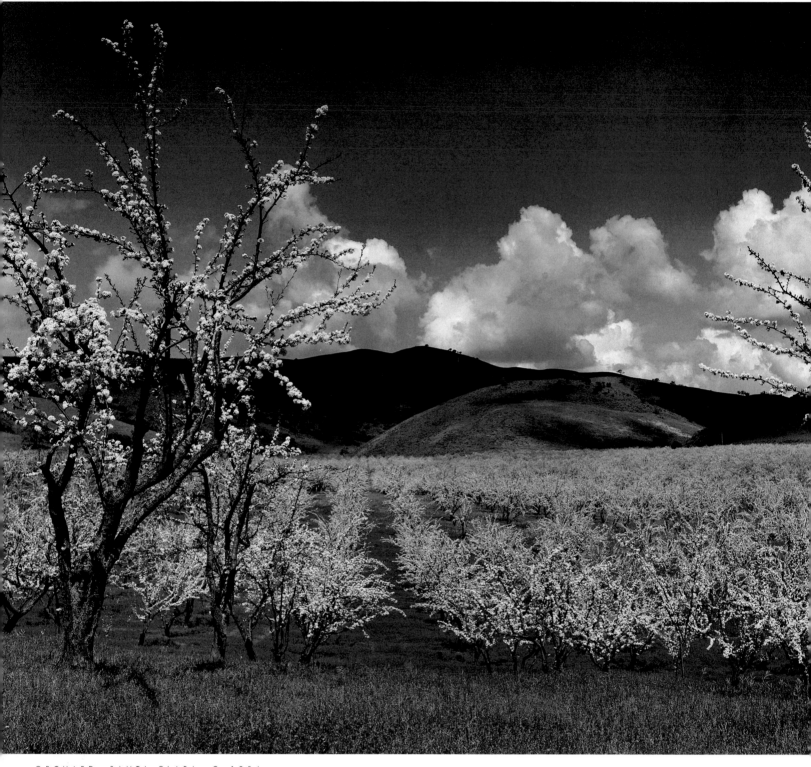

ORCHARD, SANTA CLARA, C. 1954

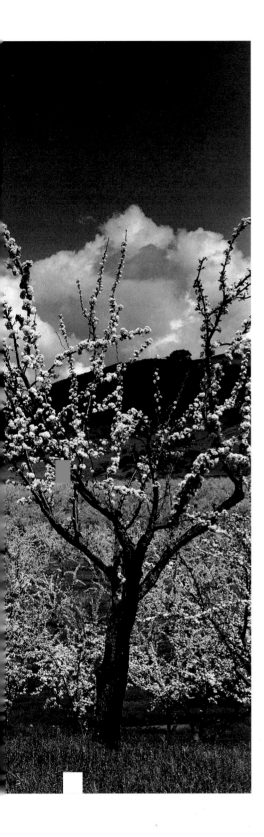

WE GO EVERY JULY from Los Angeles to pick the fruits in the summer hills of Hanford. We lived in tents and would get up early in the grey morning when it was cold. Then we all ate outdoors over a little fire. Everybody getting up from their tents and talking and calling to each other and cooking the beans. Then we go to work and stand on our feet from seven in the morning until six at night. Gee, man, I would get so tired. You know, in the fruits you dream, sleep, walk, breathe, and talk apricots — yellow and big and soft all around you. You pick 'em, you dump 'em, you squash 'em, you peel 'em, you cut 'em, you count 'em. Everything is apricots. How many you pick? How many you peel? How much buckets or trays? Always it is to eat and smell apricots. Cause apricots is pennies and sometimes they are silver dollars after you pick them a long time. Now we get lots more money in the fruits cause there is a war, and now we can go to the carnival with rich money like the boss of the ranch.

This day I tell you the boss came and paid the checks. Man, it was great. To all the working people and kids he paid them. My father and mother and me and my brother gots a hundred dollars for working three weeks, would you believe it? When I saw that check I told my mother she was fooling. The boss was just playing a game. But she said it was real money, and when I heard that I jumped up crazy I guess. I told her that check was a lot of school dresses. She said that in that check was a couch that made a bed at night for my father and brother who are tired to sleep on the little iron bed by the washing machine. And it was clothes for my brother and my father, and in it was a car. Would you believe it? A little broken car was in that check? And sure it was. Oh I tell you all was happy that night for getting money and lots clothes and food and stuff in that check.

FROM Beatrice Griffith, *American Me*, 1948

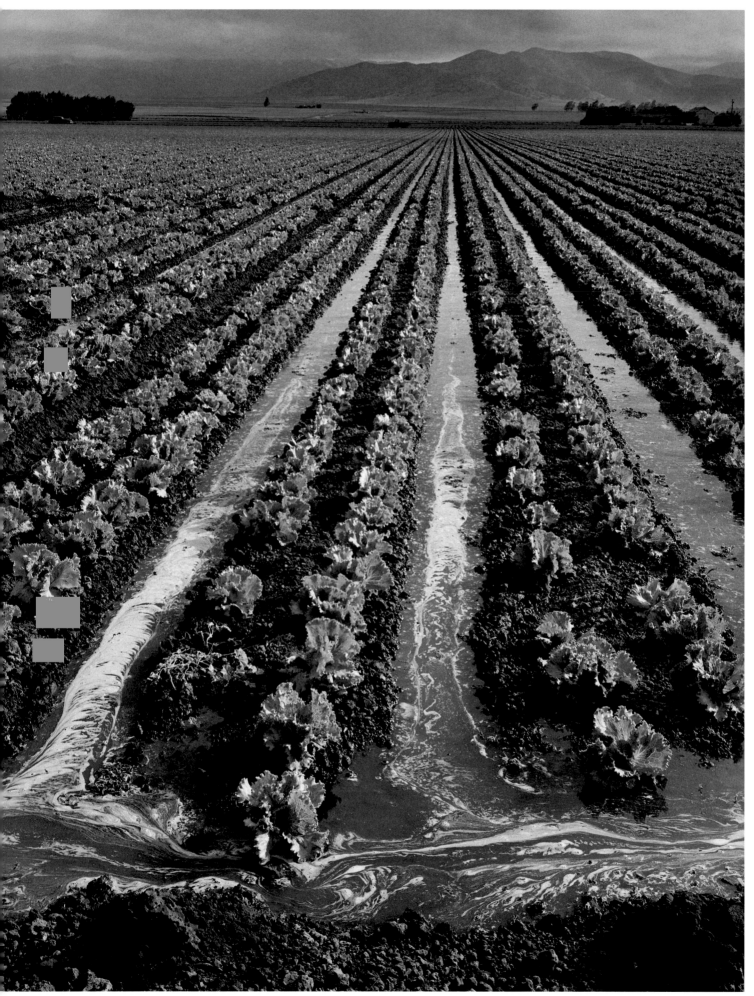

YOUNG LETTUCE FIELDS, SALINAS VALLEY, C. 1953

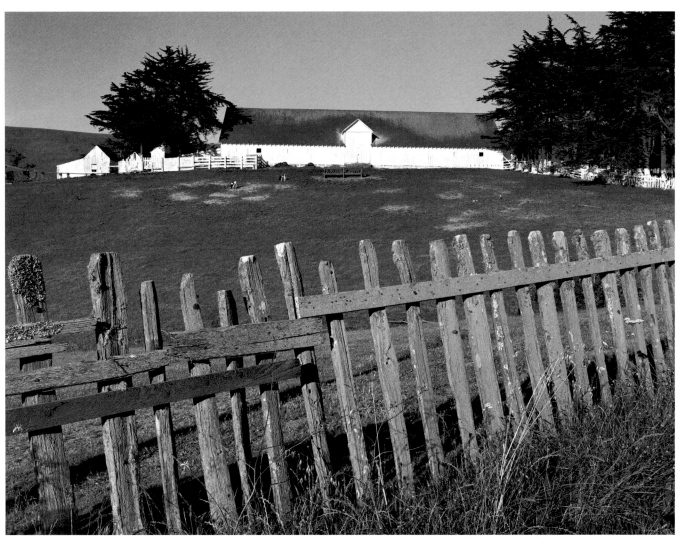

BARN AND FENCE, BOLINAS, C. 1938

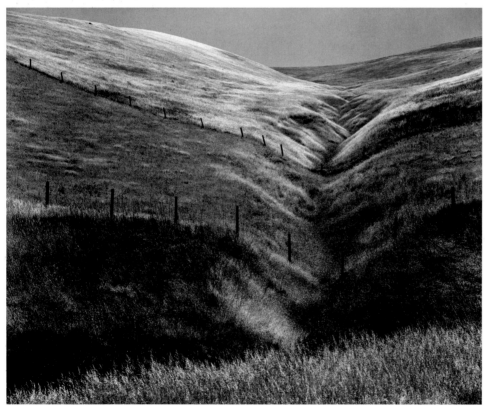

PASTURELAND, FENCE, HILLS, NEAR ALTAMONT, 1946

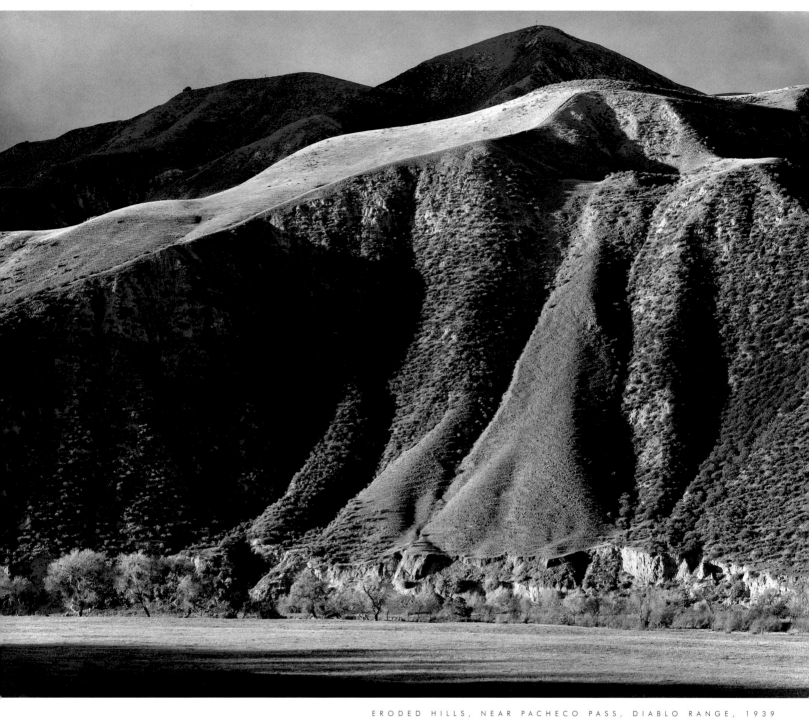

ERODED HILLS, NEAR PACHECO PASS, DIABLO RANGE, 1939

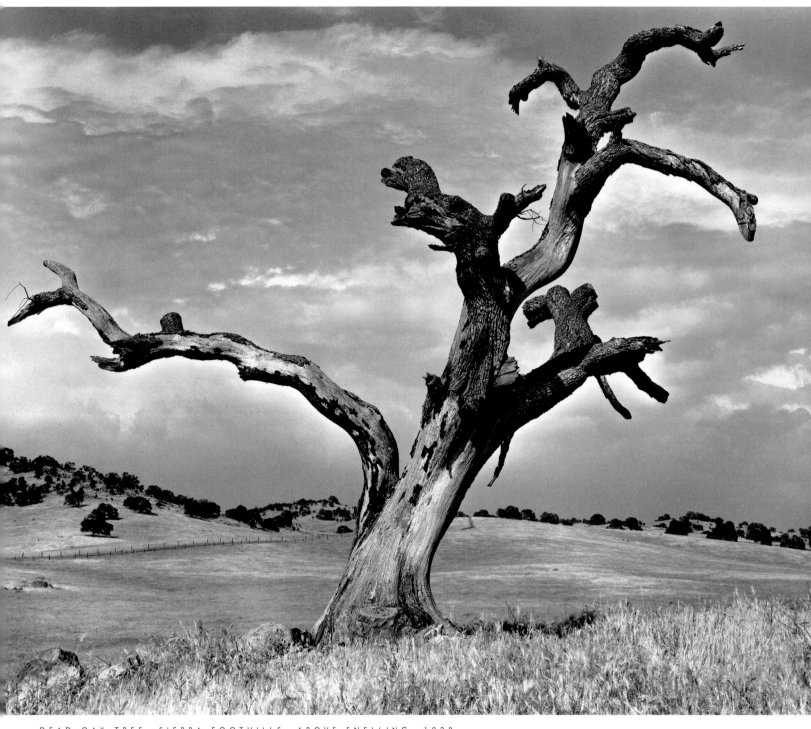

DEAD OAK TREE, SIERRA FOOTHILLS, ABOVE SNELLING, 1938

IT IS VERY EASY to sit at the bar in, say, La Scala in Beverly Hills, or Ernie's in San Francisco, and to share in the pervasive delusion that California is only five hours from New York by air. The truth is that La Scala and Ernie's are only five hours from New York by air. California is somewhere else.

Many people in the East (or "back East," as they say in California, although not in La Scala or Ernie's) do not believe this. They have been to Los Angeles or to San Francisco, have driven through a giant redwood and have seen the Pacific glazed by the afternoon sun off Big Sur, and they naturally tend to believe that they have in fact been to California. They have not been, and they probably never will be, for it is a longer and in many ways a more difficult trip than they might want to undertake, one of those trips on which the destination flickers chimerically on the horizon, ever receding, ever diminishing. I happen to know about that trip because I come from California, come from a family, or a congeries of families, that has always been in the Sacramento Valley.

You might protest that no family has been in the Sacramento Valley for anything approaching "always." But it is characteristic of Californians to speak grandly of the past as if it had simultaneously begun, *tabula rasa,* and reached a happy ending on the day the wagons started west. *Eureka* — "I Have Found It" — as the state motto has it. Such a view of history casts a certain melancholia over those who participate in it; my own childhood was suffused with the conviction that we had long outlived our finest hour. In fact that is what I want to tell you about: what it is like to come from a place like Sacramento. If I could make you understand that, I could make you understand California and perhaps something else besides, for Sacramento *is* California, and California is a place in which a boom mentality and a sense of Chekhovian loss meet in uneasy suspension; in which the mind is troubled by some buried but ineradicable suspicion that things had better work here, because here, beneath that immense bleached sky, is where we run out of continent.

FROM Joan Didion, *Slouching Towards Bethlehem,* 1961

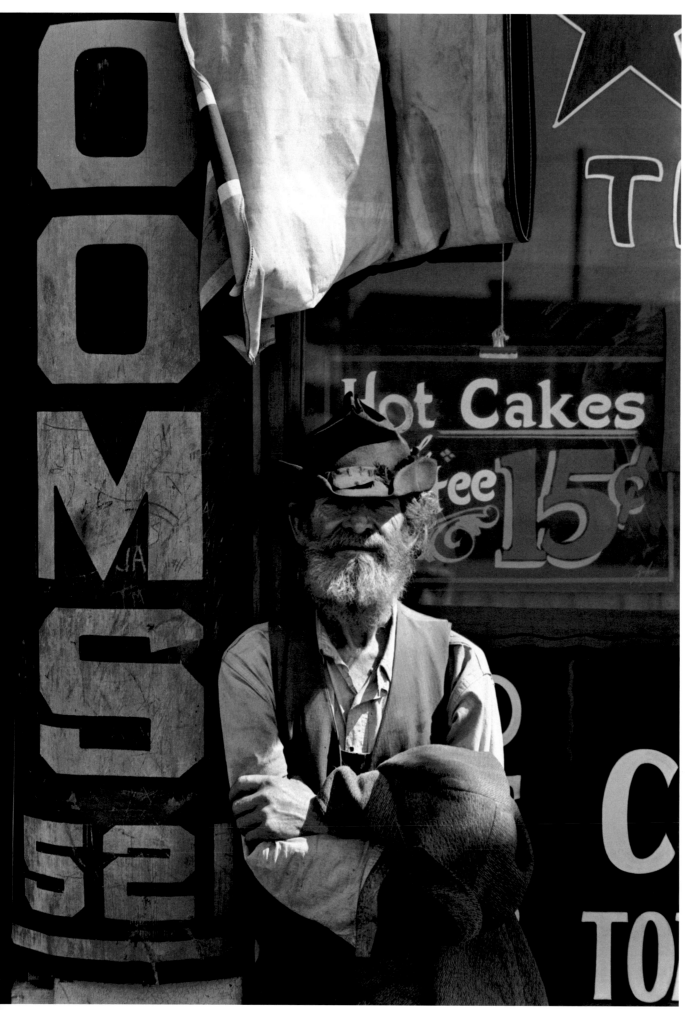

ITINERANT, MERCED, 1936

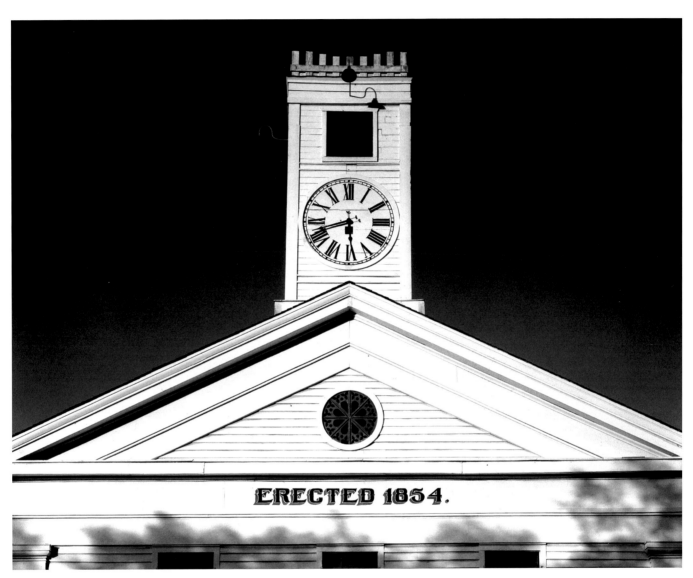

ERECTED 1854.

COURTHOUSE, MARIPOSA, 1933

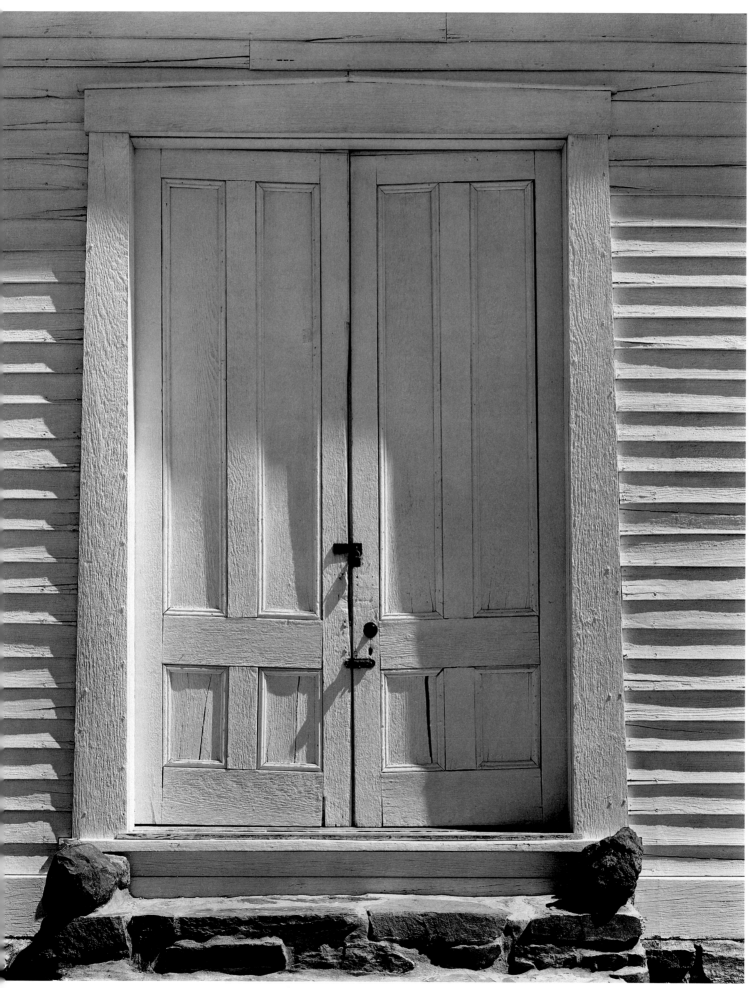

CHURCH DOOR, HORNITOS, C. 1945

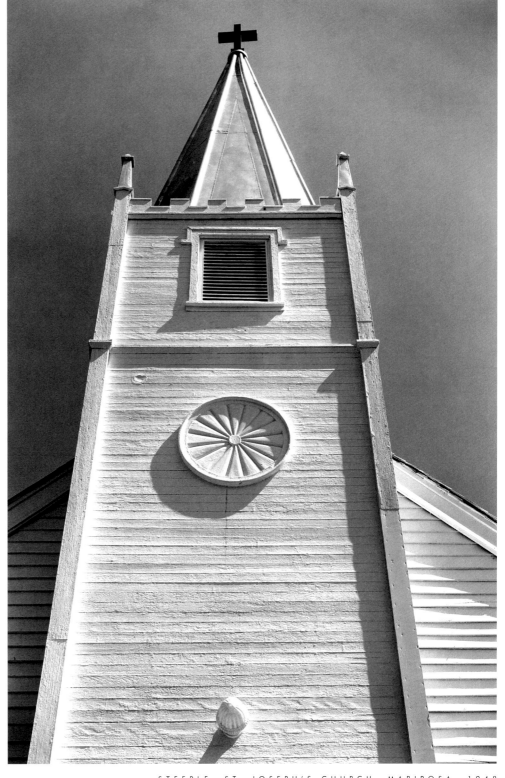

STEEPLE, ST. JOSEPH'S CHURCH, MARIPOSA, 1948

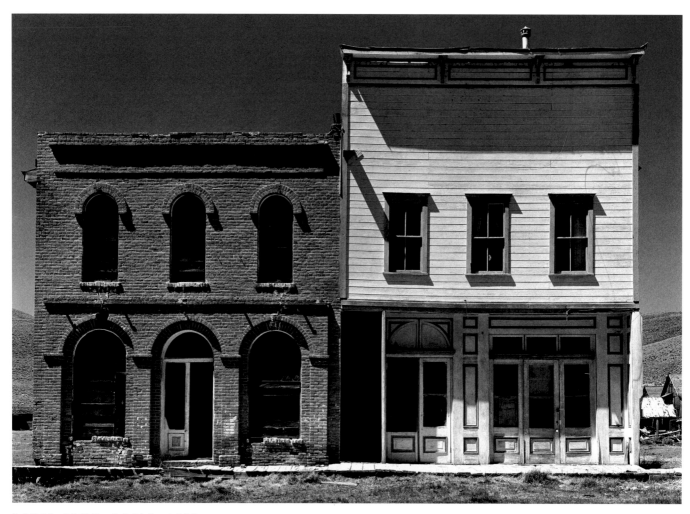

GHOST TOWN, BODIE, 1938

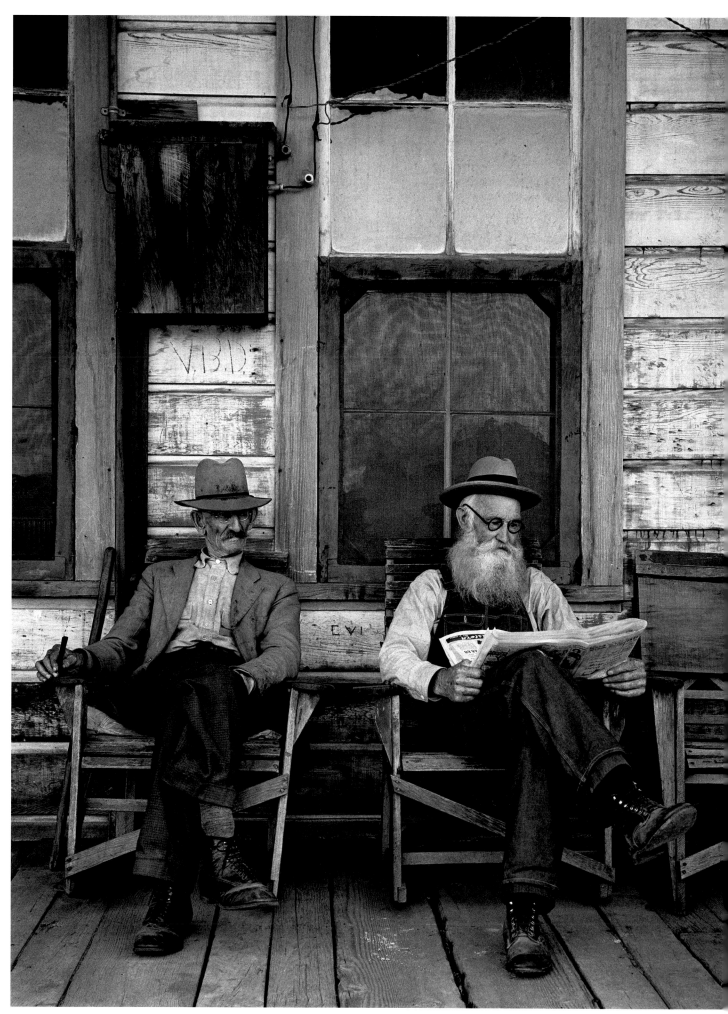

TWO MEN ON PORCH, HORNITOS, C. 1934

UNEARTHLY AND IMMENSE, Death Valley so seizes the imagination that its history, during the century white men have known it, is a history of illusions.

At first sight, it seems more an apparition than a reality.

Spectacular mountains and deserts surround it, yet somehow you are never quite prepared for what lies before you. Suddenly you notice that the distances are no longer serene and lonely. The mountains darken, sharp and turbulent as waves under an approaching storm. Pale mudhills, torn by gullies, crowd the narrow road. Pale shrubs grow in the steepening washes. Towering peaks loom ahead. Then, beyond shimmering fins and pinnacles, the ghostly gleam of the salt flats opens below.

Thousands of people, on first looking into Death Valley, have seen the landscape from a nightmare; there is no life, no water visible. Thousands have seen in the naked chaos of rocks and sediments untold wealth waiting to be mined. Geologists and naturalists have seen mysteries worth a lifetime's work to solve. And nearly all, shocked by the strangely intense beauty before them, have felt they were looking into another world.

FROM Nancy Newhall, *Death Valley*, with photographs by Ansel Adams, 1954

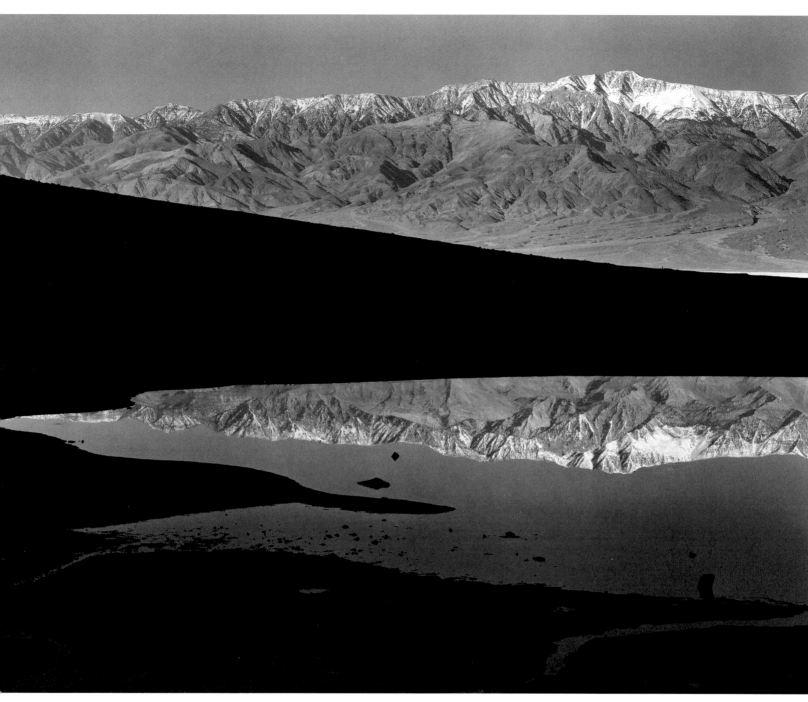

SUNRISE, BAD WATER, DEATH VALLEY NATIONAL PARK, 1948

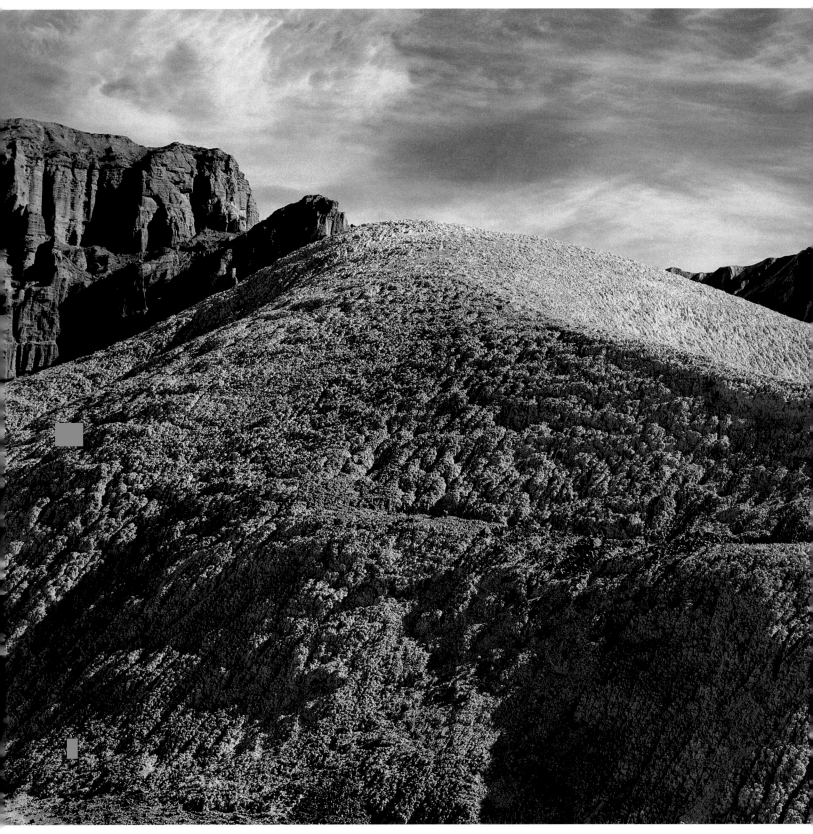

MANLY BEACON FROM ZABRISKIE POINT, DEATH VALLEY NATIONAL PARK, C. 1948

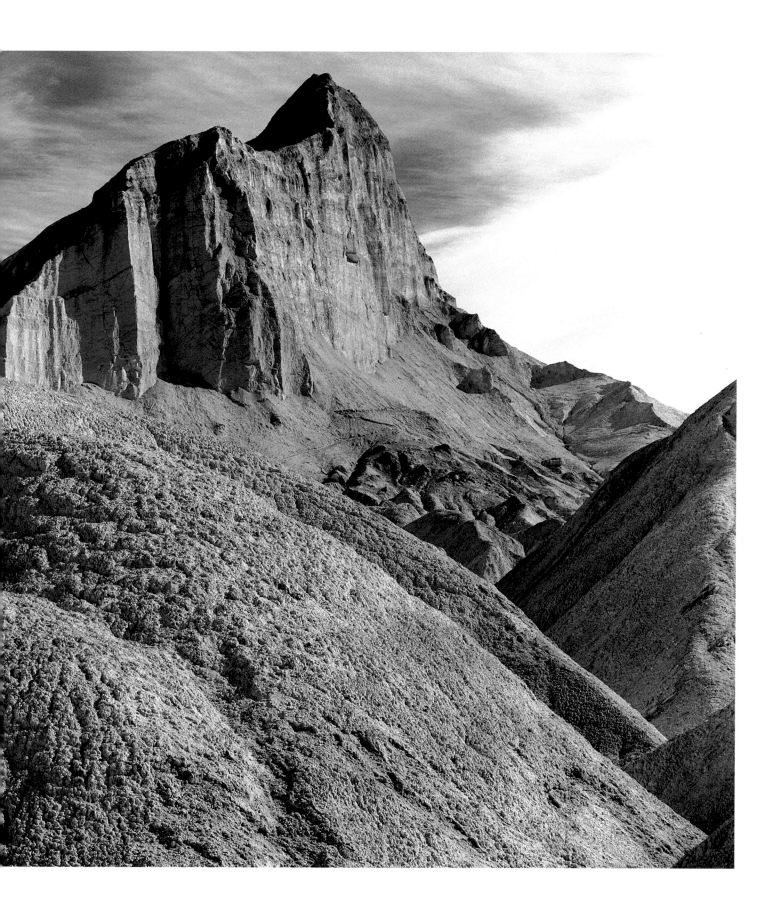

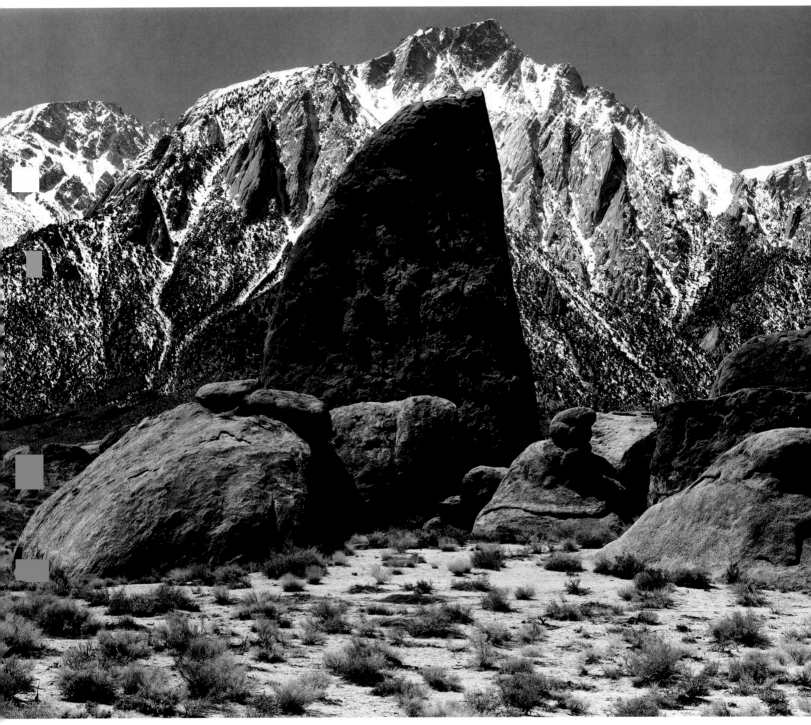

LONE PINE PEAK AND ROCKS, ALABAMA HILLS, OWENS VALLEY, 1949

A WEEK AFTER MY CLIMB I lay on the desert sand at the foot of the Inyo Range and looked up at Mount Whitney, realizing all its grand individuality, and saw the drifting clouds interrupt a sun-brightened serenity by frown after frown of moving shadow; and I entered for a moment deeply and intimately into that strange realm where admiration blends with superstition, that condition in which the savage feels within him the greatness of a natural object, and forever after endows it with consciousness and power. For a moment I was back in the Aryan myth days, when they saw afar that snowy peak, and called it Dhavalagiri (white elephant), and invested it with mystic power.

These peculiar moments, rare enough in the life of a scientific man, when one trembles on the edge of myth-making, are of interest, as unfolding the origin and manner of savage beliefs, and as awakening the . . . germ of primitive manhood which is buried within us all under so much culture and science.

This was the drift of my revery as I lay basking on the hot sands of Inyo, realizing fully the geological history and hard, materialistic reality of Mount Whitney, its mineral nature, its chemistry; yet archaic impulse even then held me, and the gaunt, gray old Indian who came slowly toward me must have subtly felt my condition. . . .

At last he drew an arrow, sighted along its straight shaft, bringing the obsidian head to bear on Mount Whitney, and in strange fragments of language told me that the peak was an old, old man who watched this valley and cared for the Indians, but who shook the country with earthquakes to punish the whites for injustice toward his tribe.

I looked at his whitened hair and keen, black eye. I watched the spare, bronze face, upon which was written the burden of a hundred dark and gloomy superstitions; and as he trudged away across the sands, I could but feel the liberating power of modern culture which unfetters us from the more than iron bands of self-made myths. My mood vanished with the savage, and I saw the great peak only as it really is, a splendid mass of granite, 14,887 feet high, ice-chiseled and storm-tinted, a great monolith left standing amid the ruins of a bygone geological empire.

FROM Clarence King, *Mountaineering in the Sierra Nevada*, 1871

MONO LAKE lies in a lifeless, treeless, hideous desert, eight thousand feet above the level of the sea, and is guarded by mountains two thousand feet higher, whose summits are always clothed in clouds. This solemn, silent, sailless sea — this lonely tenant of the loneliest spot on earth — is little graced with the picturesque. It is an unpretending expanse of grayish water, about a hundred miles in circumference, with two islands in its centre, mere upheavals of rent and scorched and blistered lava, snowed over with gray banks and drifts of pumice-stone and ashes, the winding sheet of the dead volcano, whose vast crater the lake has seized upon and occupied.

The lake is two hundred feet deep, and its sluggish waters are so strong with alkali . . . our laundry work was easy. We tied the week's washing astern of our boat, and sailed a quarter of a mile, and the job was complete, all to the wringing out. If we threw the water on our heads and gave them a rub or so, the white lather would pile up three inches high. . . .

There are no fish in Mono Lake — no frogs, no snakes, no polliwogs — nothing, in fact, that goes to make life desirable. Millions of wild ducks and sea-gulls swim about the surface, but no living thing exists *under* the surface, except a white feathery sort of worm, one half an inch long, which looks like a bit of white thread frayed out at the sides. . . .

Mono Lake is a hundred miles in a straight line from the ocean — and between it and the ocean are one or two ranges of mountains — yet thousands of sea-gulls go there every season to lay their eggs and rear their young. . . . The islands in the lake being merely huge masses of lava, coated over with ashes and pumice-stone, and utterly innocent of vegetation or anything that would burn; and sea-gulls' eggs being entirely useless to anybody unless they be cooked, Nature has provided an unfailing spring of boiling water on the largest island, and you can put your eggs in there, and in four minutes you can boil them as hard as any statement I have made during the past fifteen years. Within ten feet of the boiling spring is a spring of pure cold water, sweet and wholesome. So, in that island you get your board and washing free of charge. . . .

Half a dozen little mountain brooks flow into Mono Lake, but *not a stream of any kind flows out of it.* It neither rises nor falls, apparently, and what it does with its surplus water is a dark and bloody mystery.

FROM Mark Twain, *Roughing It,* 1872

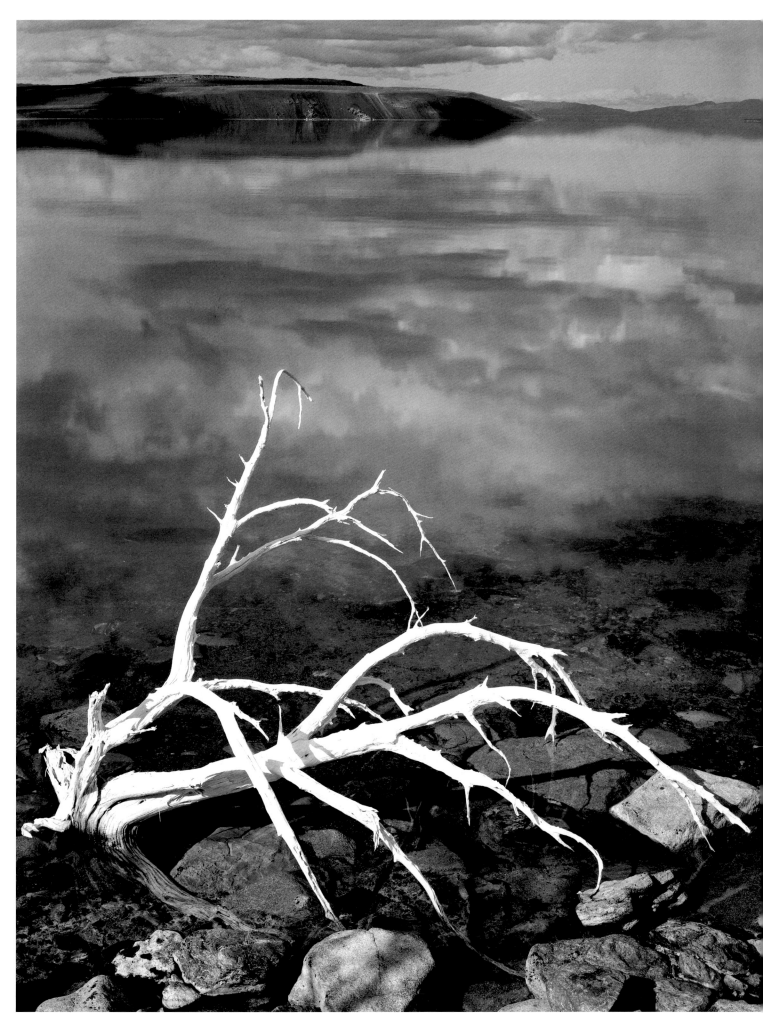

WHITE BRANCHES, MONO LAKE, 1947

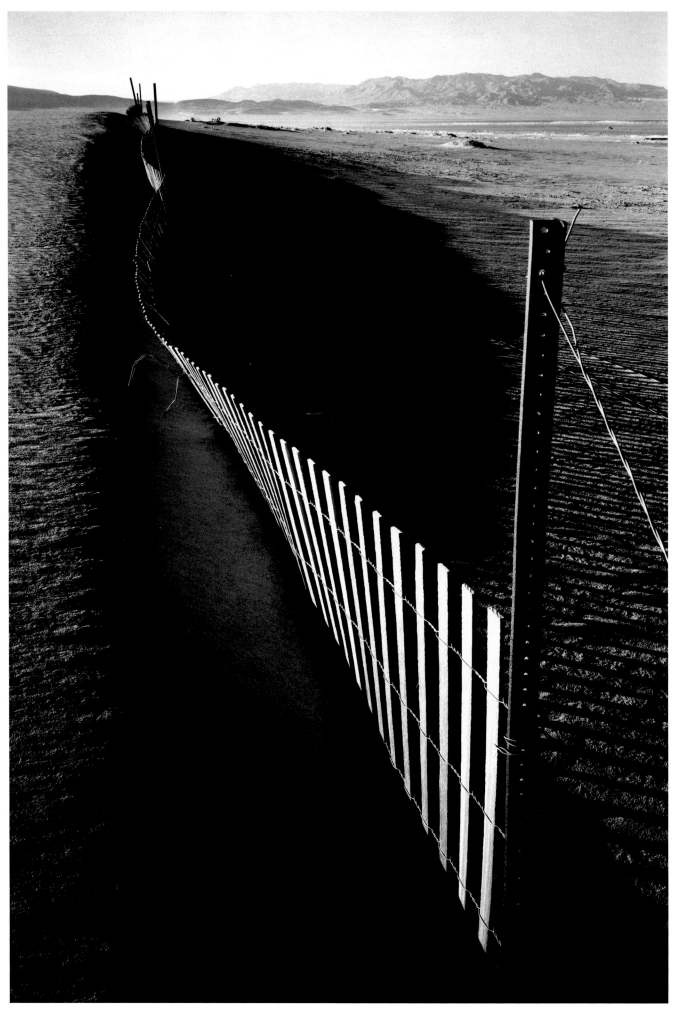

SAND FENCE, NEAR KEELER, 1948

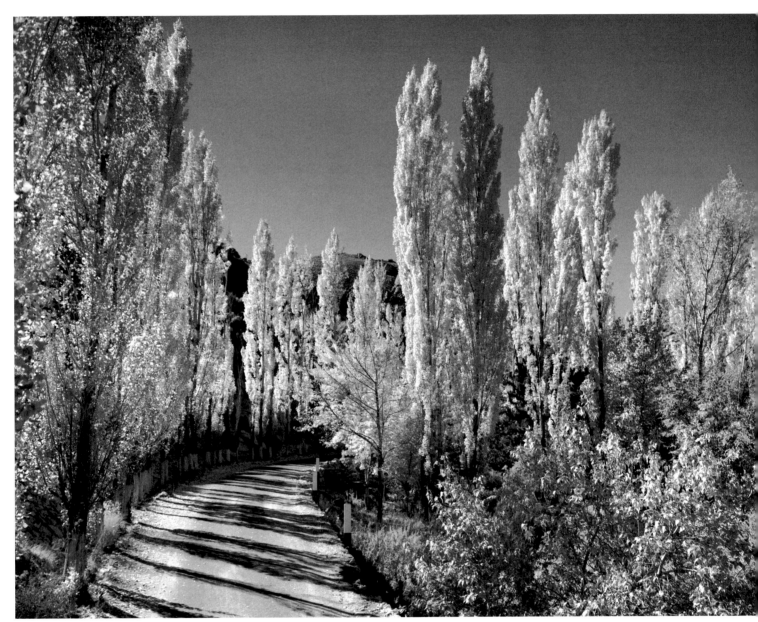

POPLARS, AUTUMN, OWENS VALLEY ROAD, C. 1939

F OR AN EXTREMELY LARGE percentage of the history of the world, there was no California. That is, according to present theory. I don't mean to suggest that California was underwater and has since come up. I mean to say that of the varied terranes and phisographic provinces that we now call California nothing whatever was there. The continent ended far to the east, the continental shelf as well. Where California has come to be, there was only blue sea reaching down some miles to ocean-crustal rock, which was moving, as it does, into subduction zones to be consumed. Ocean floors with an aggregate area many times the size of the present Pacific were made at spreading centers, moved around the curve of the earth, and melted in trenches before there ever was so much as a kilogram of California. Then, a piece at a time — according to present theory — parts began to assemble. An island arc here, a piece of a continent there — a Japan at a time, a New Zealand, a Madagascar — came crunching in upon the continent and have thus far adhered. Baja is about to detach. A great deal more may go with it. Some parts of California arrived head on, and others came sliding in on transform faults, in the manner of that Sierra granite west of the San Andreas. In 1906, the jump of the great earthquake — the throw, the offset, the maximum amount of local displacement as one plate moved with respect to the other — was something like twenty feet. The dynamics that have pieced together the whole of California have consisted of tens of thousands of earthquakes as great as that — tens of thousands of examples of what people like to singularize as "the big one" — and many millions of earthquakes of lesser magnitude.

FROM John McPhee, *Assembling California*, 1993

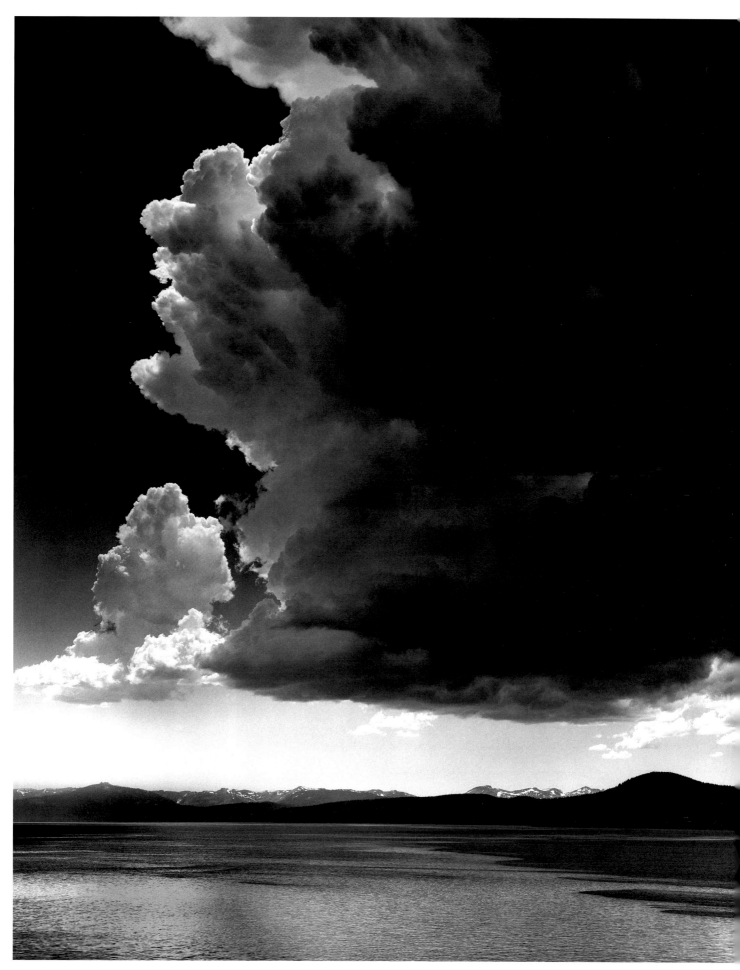

THUNDERCLOUD, LAKE TAHOE, 1938

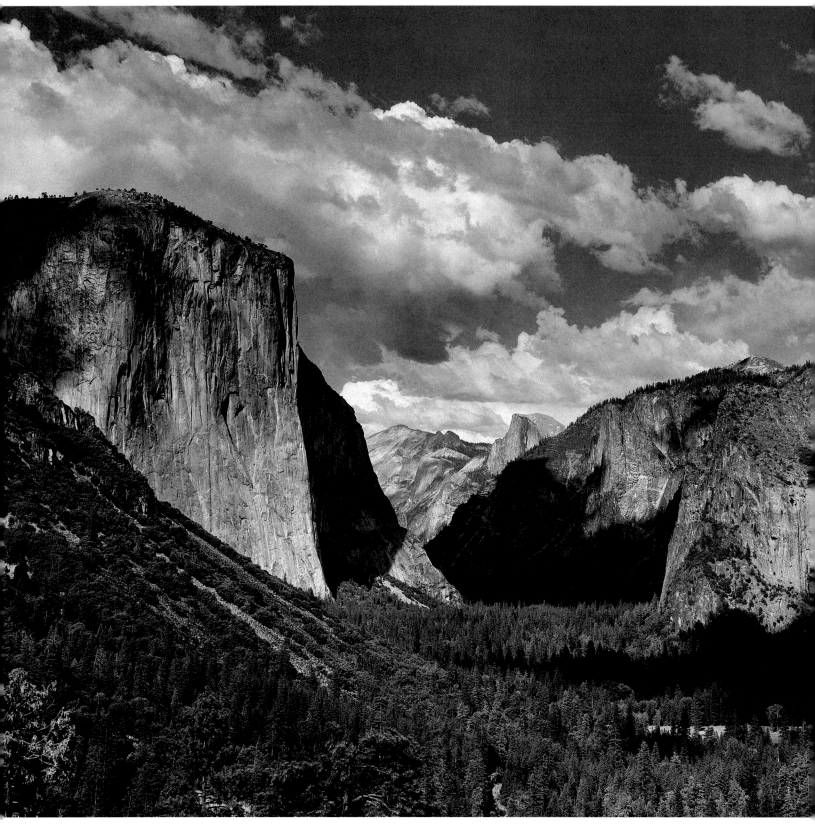

YOSEMITE VALLEY VIEW, SUMMER, YOSEMITE NATIONAL PARK, C. 1944

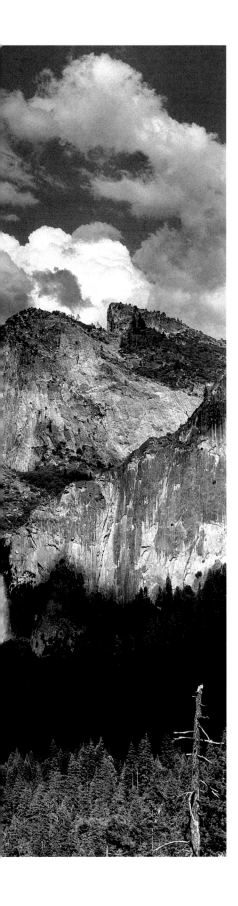

THE ROAD TO YO SEMITE, like the way of life, is narrow and difficult, but the end, like the end of a well-spent life, is glorious beyond the highest anticipation.
— JAMES VICK, Rochester, New York

I was never so near Heaven in my life.
— H. WINDEL, San Francisco

I have spent seventeen days in Yo Semite, and I never left a place with so much regret in my life. I have several times visited all the noted places of Europe, and many that are out of the regular tourist's round: I have crossed the Andes in three different places, and been conducted to the sights deemed most remarkable: I have been among the charming scenery of the Sandwich Islands, the Himalayas of India, and the mountain districts of Australia, but never have I seen so much of sublime grandeur, relieved by so much beauty, as that I have witnessed in Yo Semite.
— HON. ROBT. MARSHAM, Maidstone, Kent, England

Here speaks the voice of God, and here his power is seen.
Let man be dumb.
— REV. W. P. ABBOTT, New York City

Real estate is very high hereabouts!
— DERRICK DODD, *San Francisco Evening Post*

This spoils one for any other scenery upon earth.

— HIS GRACE, the Duke of Sutherland, England

Speech may be silver, but in this marvelous vale, where
grandeur and majesty have met, "Silence is golden."

— E. EDMONSTON, Santa Barbara, California

Suddenly, as I rode along, I heard a shout. I knew the valley
had revealed itself to those who were at the front of the line.
I turned my head away. I couldn't look until I had tied my horse.
Then I walked down to the ledge and crawled out upon the
over-hanging rocks. I believe some men walk out there — it's a
dull sort of a soul who can do that. In all my life, let it lead
me where it may, I think I shall see nothing else so grand, so
awful, so sublime, so beautiful — beautiful with a beauty not
of this earth — as that vision of the Valley. How long I sat there
I never shall know. I brought the picture away with me; I have
only to shut my eyes and I see it as I saw it in that hour of
hours. I think I shall see nothing else so sublime and beautiful,
till, happily, I stand within the gates of the Heavenly City.

— SIDNEY ANDREWS' "Letter to the Boston Advertiser"

I may as well try to measure a rainbow with a two-foot rule
as to take this in.

— WM. DARBACK, New York City

FROM J. M. Hutchings, *In the Heart of the Sierras*, 1886

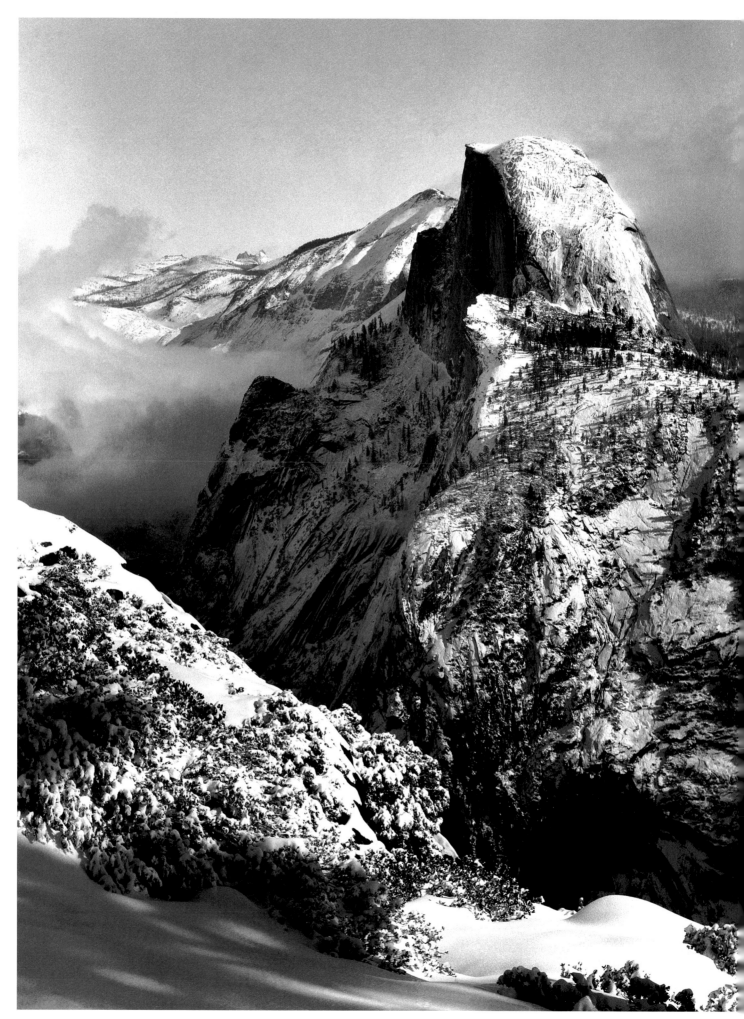

HALF DOME, WINTER, FROM GLACIER POINT, YOSEMITE NATIONAL PARK, C. 1940

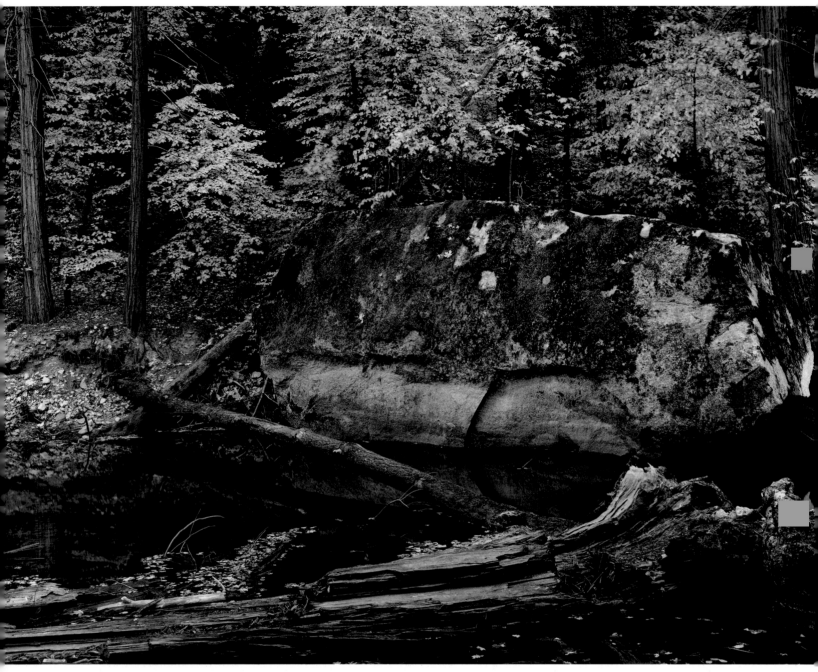

TENAYA CREEK, AUTUMN FOREST, YOSEMITE NATIONAL PARK, C. 1952

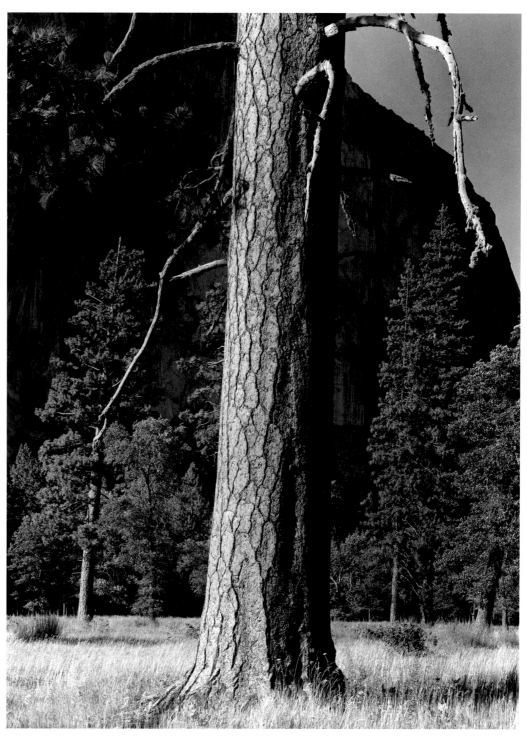

YELLOW PINE TREE, EL CAPITAN MEADOW, YOSEMITE NATIONAL PARK, 1940

THE LEGEND OF TU-TOK-A-NU'-LA

Long ago two little bear cubs living in the Valley of Ah-wah'nee went down to the river to swim. They paddled and splashed about to their hearts' content. The cubs then returned to shore and climbed up on a huge boulder that stood beside the water. They lay down to dry themselves in the warm sunshine, and very soon they fell asleep. The bear cubs slept so soundly that they did not awaken. Through sleeps, moons and snows, both winter and summer, they slumbered on.

Meanwhile, the great rock upon which they slept began to rise. It rose day and night, little by little, until it had lifted them up high into the sky. In this way the cubs were carried out of sight and beyond voice of their bird and animal friends below. They were lifted up into the blue heavens, far up, far up, until the little bears scraped their faces against the moon. Still they slumbered and slept year after year, safe among the clouds.

The bird and animal people of Ah-wah'-nee missed the bear cubs, and cried for them. One day they all assembled together in the hope of bringing down the little bears from the top of the great rock. One at a time, each animal made a spring up the face of the wall as far as he could leap.

The little mouse could only jump up the breadth of a hand. The rat jumped two handbreadths, and the raccoon made it a little further. The grizzly bear made a mighty leap far up the wall, but fell back in vain like all the others. Last of all, the mountain lion tried, and he jumped up further than any other animal. But he, too, fell flat on his back.

Then along came Tul-tak-a-na, an insignificant measuring worm, which even the mouse could crush with his foot. The measuring worm began to creep up the rock. Step by step, a little at a time, he measured his way up. Before long, he was above the mountain lion's jump, and soon he had inched out of sight. In this way the worm crawled up and up through many sleeps for about one whole snow, and at last he reached the top.

Measuring worm picked up the bear cubs and in the same way he went up, took them safely down to the floor of the valley. Since that time, the boulder that grew to be a great high rock has been called Tu-tok-a-nu'-la [El Capitan] in honor of Tu-tak-a-na, the measuring worm.

FROM "The Legend of Tu-tok-a-nu'-la," *Legends of the Yosemite Miwok*

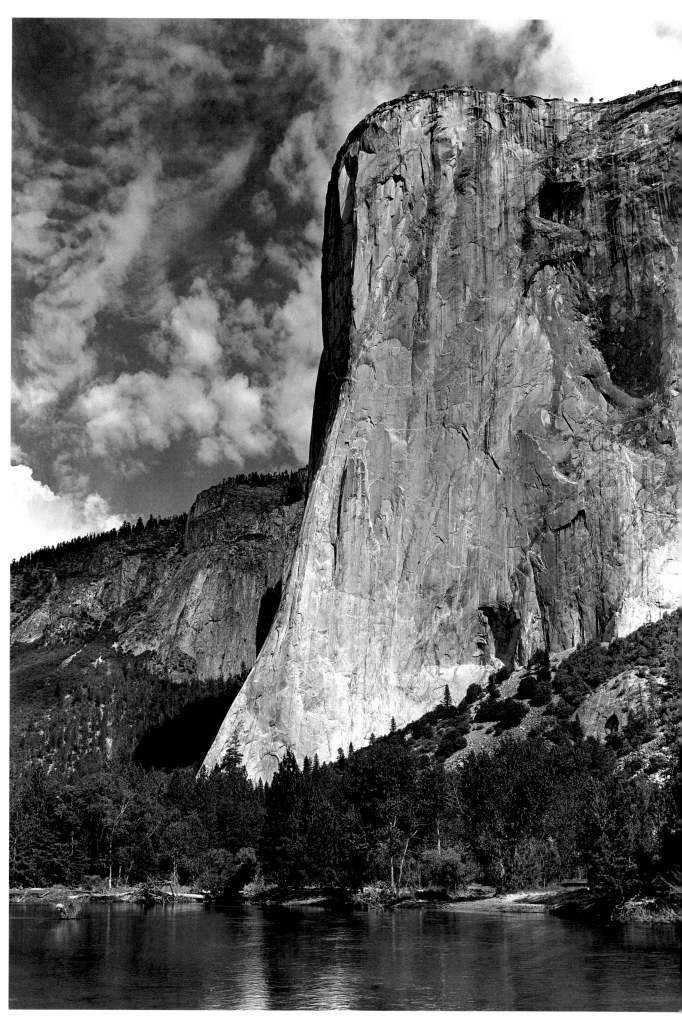

EL CAPITAN AND THE MERCED RIVER, CLOUDS, YOSEMITE NATIONAL PARK, C. 1952

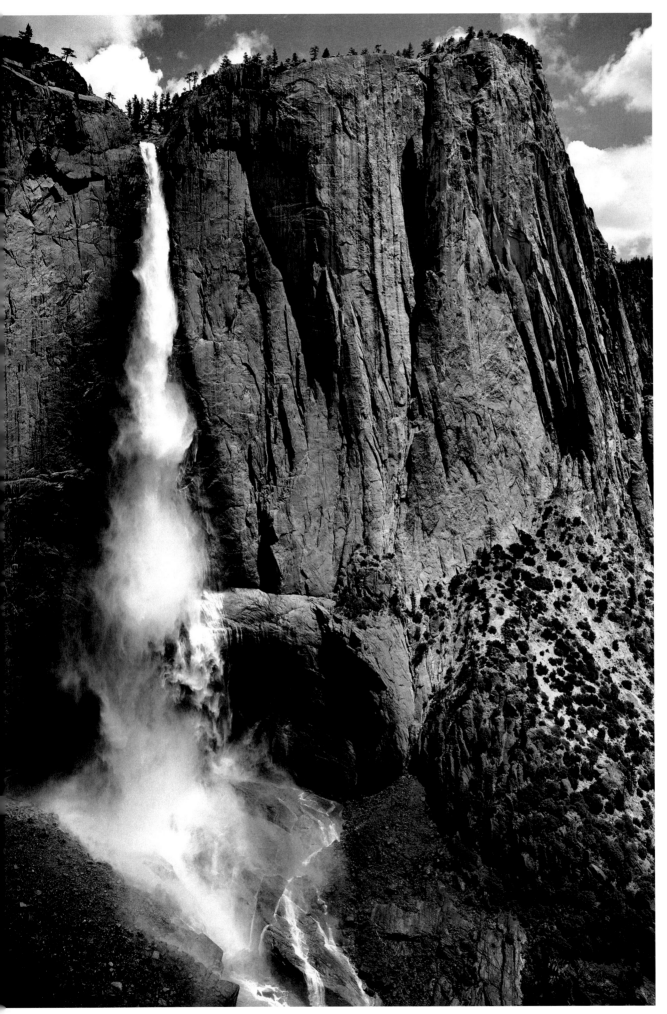

UPPER YOSEMITE FALLS AND YOSEMITE POINT, YOSEMITE NATIONAL PARK, 1945

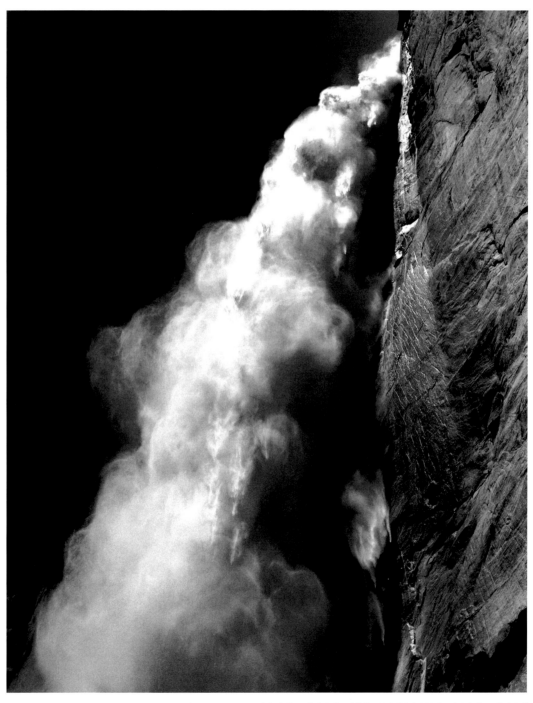

UPPER YOSEMITE FALLS FROM FERN LEDGE, YOSEMITE NATIONAL PARK, 1946

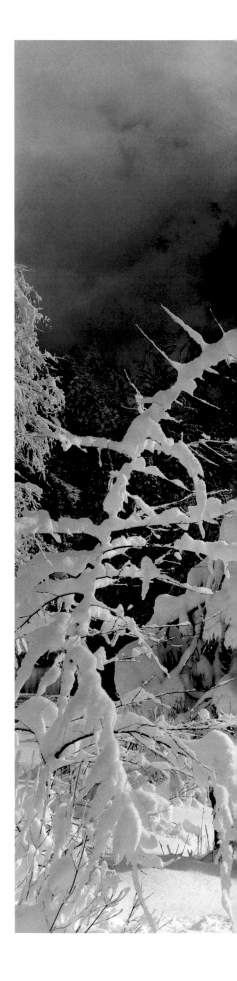

J UST AS THE DARK OF EVENING FELL, the clouds gave rain and sleet which soon changed to snow, coming in large matted flakes. All through the long dark night it fell. Every peak and dome, every bench and tablet had their share of winter jewelry, as we our daily bread; and the nodding tassels of the pine, and the plumes of the Libocedrus, and the naked oaks shared in the first precious gift of the winter sky, and blessed are the eyes that saw morning open upon the glory accomplished in that first storm night. . . .

I rode to the very end of the valley gazing from side to side, thrilled almost to pain with the glorious feast of snowy diamond loveliness. The walls of our temple were decorated with exact reference to each other. The eye mounted step by step upon the dazzling tablets and flowering shrubs which ruled the mountain walls like a sheet of paper, and published the measure of their sublime height. The sky was mostly clear, but here and there a fleece of muffling cloud lingered about the canyons and larger tablets, or floated up the perpendicular steep like a balloon, as if taking a last look at the night's work accomplished, to see if it could spy a place where a flake or two more was needed. A filmy veiling, wondrous fine in texture, hid the massive front of Capitan. Only in little spots with melted edges did the solemn gray of the rock appear. "El Capitan smokes mucha este dia," said a Spaniard who rode with me.

From end to end of the temple, from the shrubs and half-buried ferns of the floor to the topmost ranks of jeweled pine spires, it is all one finished unit of divine beauty, weighed in the celestial balances and found perfect.

FROM John Muir, "My First Winter in Yosemite Valley, December 1869," *John of the Mountains*, 1938

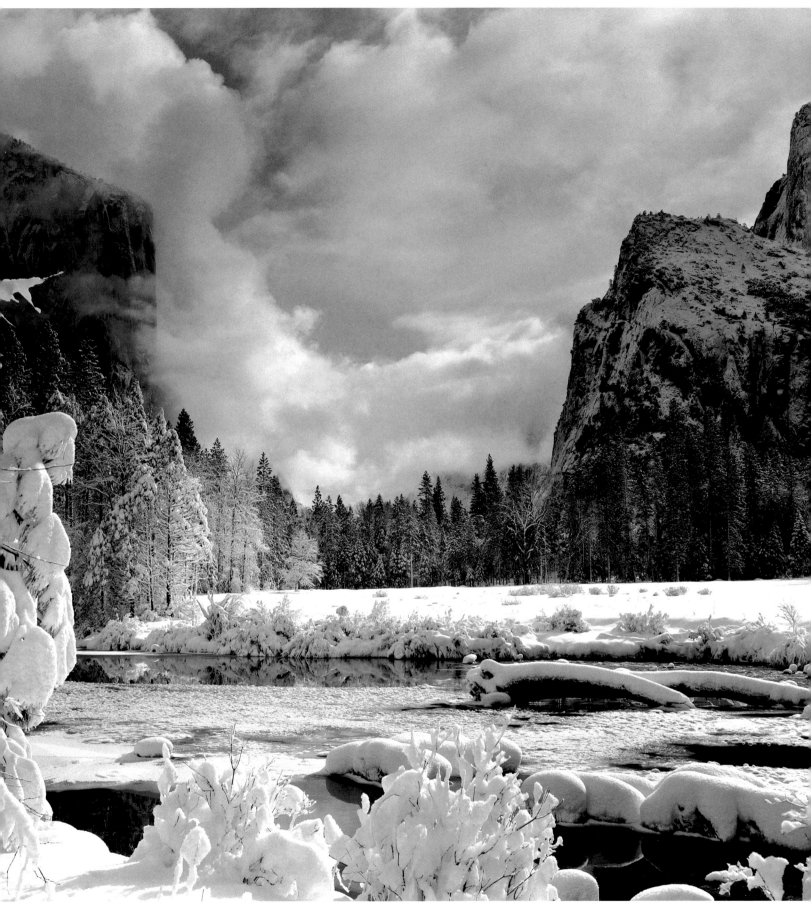

GATES OF THE VALLEY, WINTER, YOSEMITE NATIONAL PARK, C. 1938

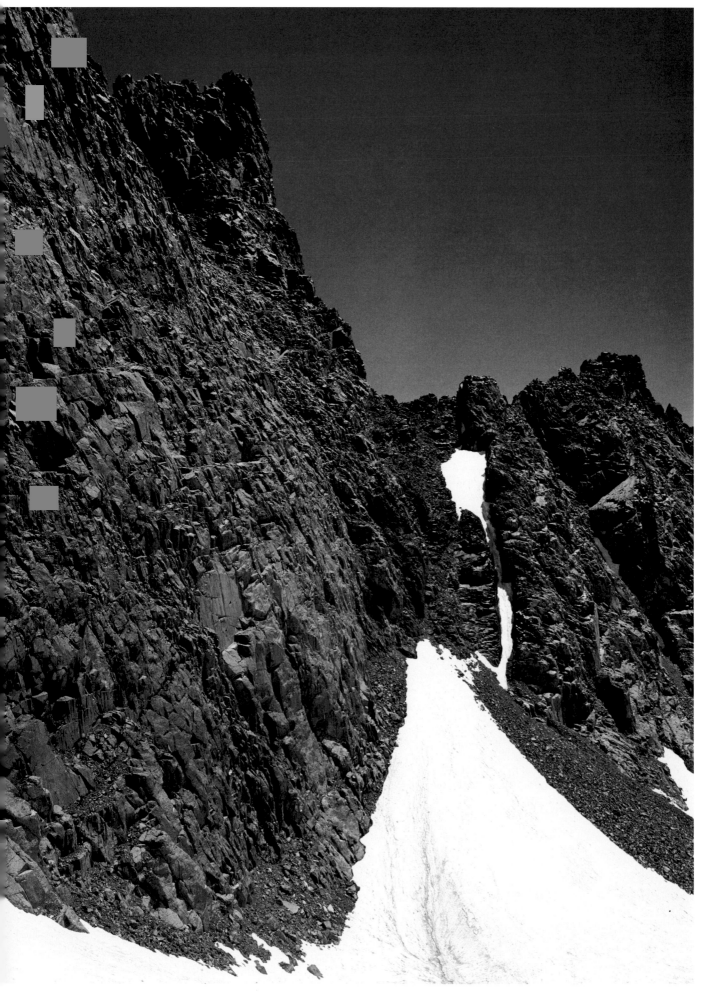

EAST CLIFF OF MICHAEL'S MINARET, SIERRA NEVADA, C. 1935

SOMETHING WILL HAVE gone out of us as a people if we ever let the remaining wilderness be destroyed; if we permit the last virgin forests to be turned into comic books and plastic cigarette cases; if we drive the few remaining members of the wild species into zoos or to extinction; if we pollute the last clear air and dirty the last clean streams and push our paved roads through the last of the silence, so that never again will Americans be free in their own country from the noise, the exhausts, the stinks of human and automotive waste. And so that never again can we have the chance to see ourselves single, separate, vertical and individual in the world, part of the environment of trees and rocks and soil, brother to the other animals, part of the natural world and competent to belong in it. Without any remaining wilderness, we are committed wholly, without chance for even momentary reflection and rest, to a headlong drive into our technological termite-life, the Brave New World of a completely man-controlled environment. We need wilderness preserved — as much of it as is still left, and as many kinds — because it was the challenge against which our character as a people was formed. The remainder and the reassurance that it is still there is good for our spiritual health even if we never once in ten years set foot in it. It is good for us when we are young, because of the incomparable sanity it can bring briefly, as vacation and rest, into our insane lives. It is important to us when we are old simply because it is there — important, that is, simply as idea.

FROM Wallace Stegner, *The Sound of Mountain Water,* 1969

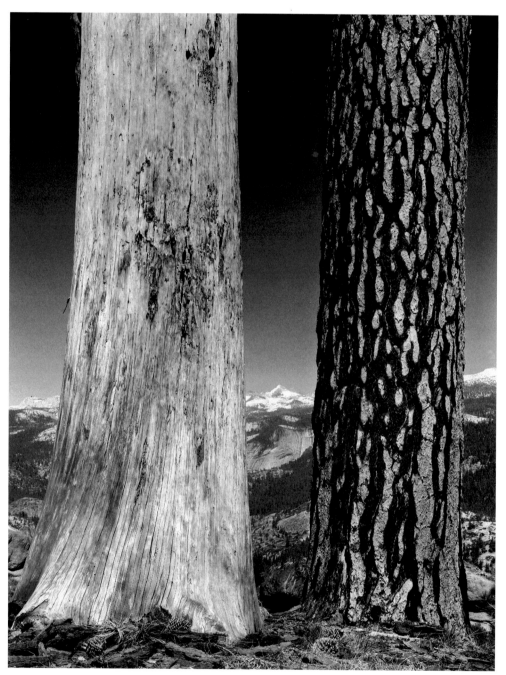

TREES NEAR WASHBURN POINT, YOSEMITE NATIONAL PARK, C. 1945

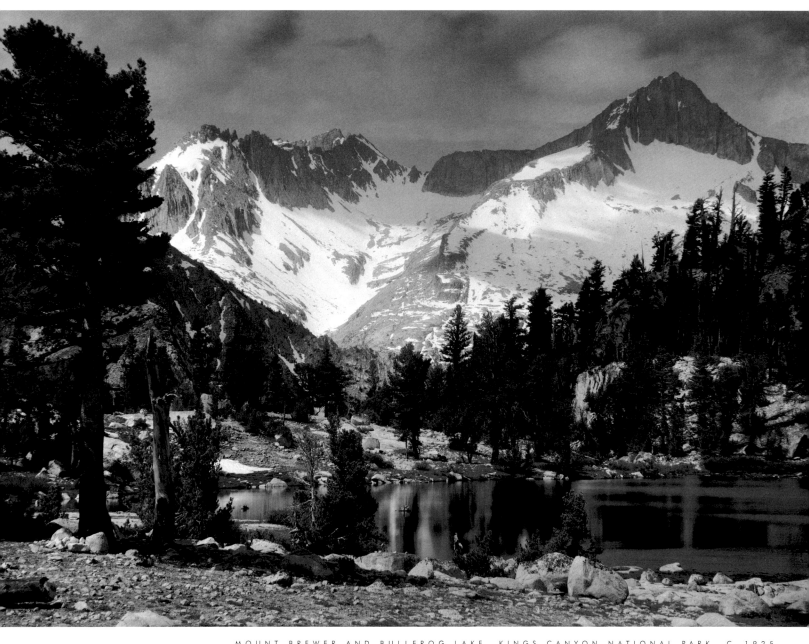

MOUNT BREWER AND BULLFROG LAKE, KINGS CANYON NATIONAL PARK, C. 1925

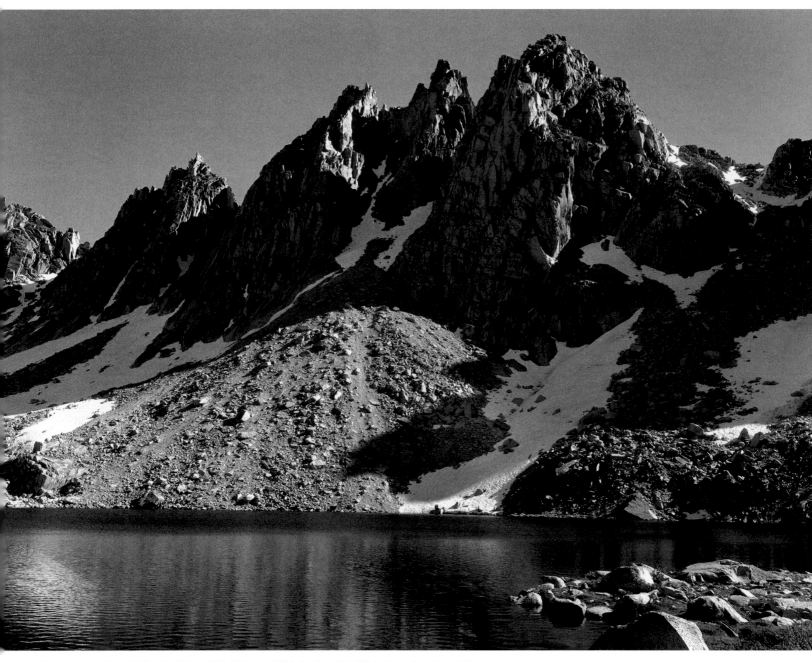

KEARSARGE PINNACLES, KINGS CANYON NATIONAL PARK, C. 1925

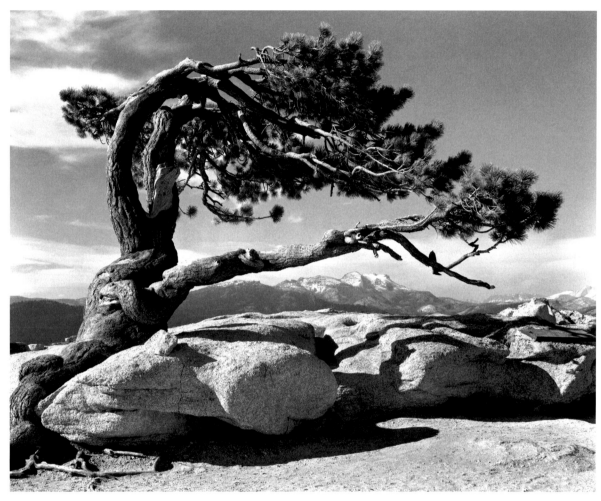

JEFFREY PINE, SENTINEL DOME, YOSEMITE NATIONAL PARK, 1945

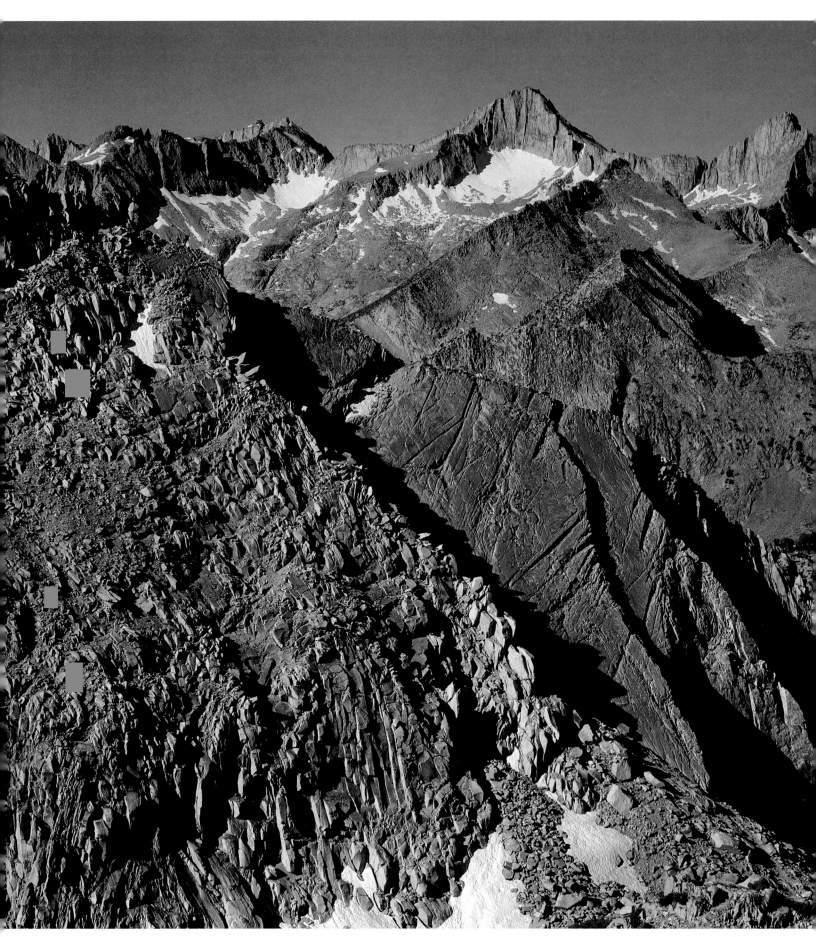

MOUNT BREWER GROUP FROM GLEN PASS, KINGS CANYON NATIONAL PARK, 1925

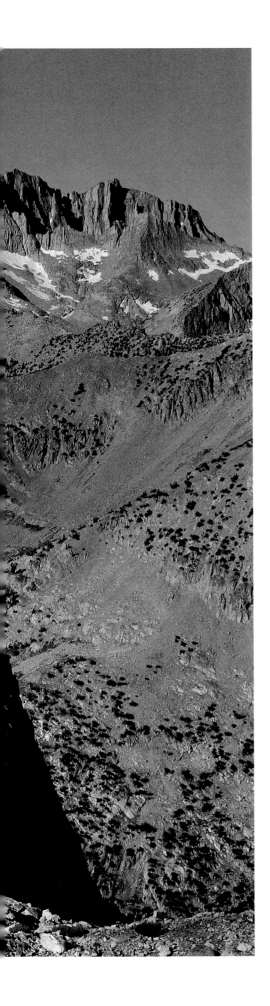

FOR A GRAPHIC AND MEMORABLE report of the contours of any country, see always the aboriginal account of its making. That will give you the lie of the land as no geographer could sketch it forth for you. California was made by Padahoon the Sparrow-Hawk and the Little Duck, who brooded on the face of the waters in the Beginning of Things. . . .

Padahoon, being wearied of going to and fro under the heavens, said to the Little Duck that it was time there should be mountains; so the Little Duck dived and brought up the primordial mud of which even the geographers are agreed mountains are made.

As he brought it the Sparrow-Hawk built a round beautiful ring of mountains enclosing a quiet space of sea. Said the Little Duck, "I choose this side," coming up with his bill full of mud toward the west. Whereupon the Sparrow-Hawk built the other side higher. When it was all done and the Little Duck surveyed it, he observed, as people will to this day, the discrepancy between the low western hills and the high Sierras, and he thought the builder had not played him fair. "Very well, then," said the Sparrow-Hawk, "since you are resolved to be so greedy," and he bit out pieces of the Sierras with his bill, and threw them over his shoulder.

You can see the bites still deep and sharp about Mt. Whitney.

But the Little Duck would not be satisfied; he took hold by the great bulk of Shasta and began to pull, and Padahoon pulled on his side until the beautiful ring was pulled out in a long oval and began to break on the west where the bay of San Francisco comes in. So they were forced to divide the mountain range north and south and make what they could of it. But the Sparrow-Hawk, remembering the pieces he had thrown over his shoulder, chose the south, where you can still see him sailing any clear day about four in the afternoon, over all his stolen territory.

FROM Mary Austin, *California, the Land of the Sun*, 1914

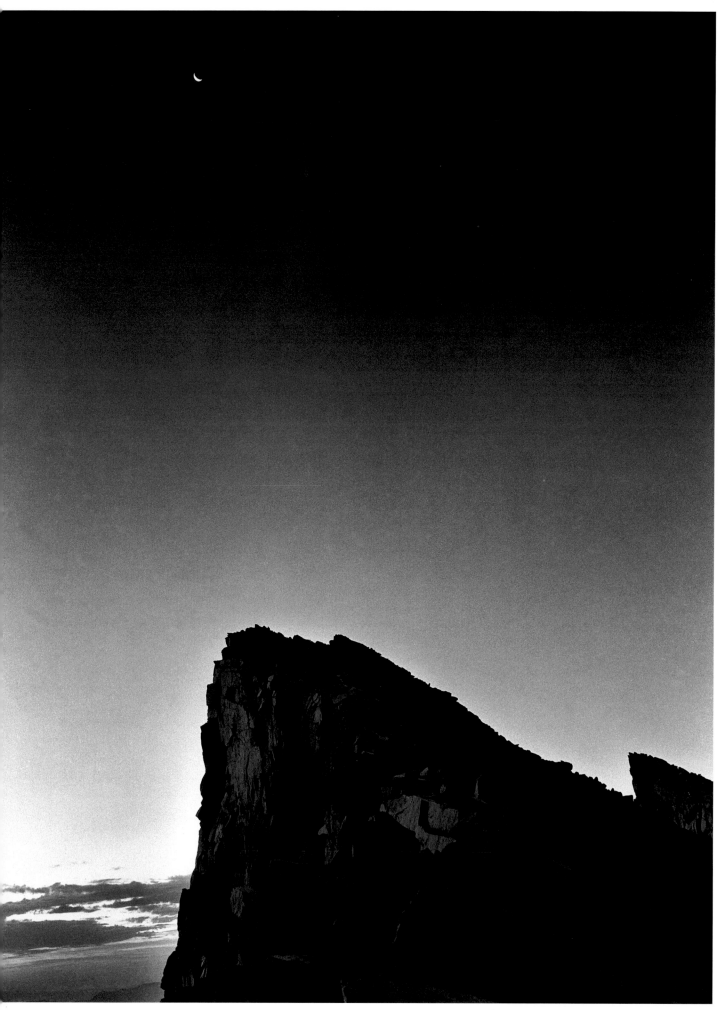

DAWN, MOUNT WHITNEY, SIERRA NEVADA, 1932

ANSEL ADAMS: CALIFORNIA — LIST OF PLATES

BIBLIOGRAPHY

AUSTIN, MARY. *California, the Land of the Sun.* New York: Macmillan Company; and London: Adams and Charles Black, 1914.

DANA, RICHARD HENRY, JR. *Two Years Before the Mast.* New York: Harper's Brothers, 1840.

DIDION, JOAN. *Slouching Towards Bethlehem.* New York: Simon and Schuster, 1961.

GRIFFITH, BEATRICE. *American Me.* Boston: Houghton Mifflin Company, 1948.

HUTCHINGS, J. M. *In the Heart of the Sierras.* Oakland: Pacific Press Publishing House, 1886.

JEFFERS, ROBINSON. "Return," from *Solstice and Other Poems.* New York: Random House, 1935.

KEROUAC, JACK. *On the Road.* New York: Viking Press, 1962.

KING, CLARENCE. *Mountaineering in the Sierra Nevada.* New York: W. W. Norton & Co., Inc., 1871.

"The Legend of Tu-tok-a-nu'-la," from *Legends of the Yosemite Miwok.* Yosemite, California: Yosemite Natural History Association, 1981.

MCPHEE, JOHN. *Assembling California.* New York: The Noonday Press, Farrar, Straus and Giroux, 1993.

MILLER, HENRY. "Topographical," from *Big Sur and the Oranges of Heironymus Bosch.* New York: New Directions, 1957.

MUIR, JOHN. "My First Winter in Yosemite Valley, December 1869," from *John of the Mountains; The Unpublished Journals of John Muir.* Boston: Houghton Mifflin Company, 1938.

NEWHALL, NANCY. *Death Valley,* with photographs by Ansel Adams. Redwood City, California: 5 Associates, 1954.

PARISH, JOHN CARL. "Comment and Historical News," *Pacific Historical Review* 1, 1932.

POST, EMILY. *By Motor to the Golden Gate.* New York and London: D. Appleton and Company, 1916.

PREUSS, CHARLES. *Exploring with Frémont: The Private Diaries of Charles Preuss, Cartographer for John C. Frémont on His First, Second, and Fourth Expeditions to the Far West.* Translated and edited by Erwin G. and Elizabeth K. Gudda. Norman, Oklahoma: University of Oklahoma Press, 1958.

STEGNER, WALLACE. Excerpt from "Coda: The Wilderness Letter" from *The Sound of Mountain Water.* New York: Doubleday, 1969.

STEINBECK, JOHN. *Travels with Charley.* New York: Viking Press, 1962.

STEVENSON, ROBERT LOUIS. "The Sea Fogs," from *Silverado Squatters.* Boston: Roberts Brothers, 1884.

TWAIN, MARK. *Roughing It.* Hartford, Connecticut: American Publishing Company, 1872.

WHITMAN, WALT. "Song of the Redwood-Tree," from *Leaves of Grass.* Philadelphia: Rees Welsh & Co., 1882.

WILDER, LAURA INGALLS. *West from Home: Letters of Laura Ingalls Wilder.* New York: Harper & Row, 1974.

ACKNOWLEDGMENTS

THE AUTHOR is grateful for permission to include the following previously copyrighted material:

Excerpt from "Notes from a Native Daughter" from *Slouching Towards Bethlehem* by Joan Didion. Copyright © 1966, 1968 by Joan Didion. Reprinted by permission of Farrar, Straus & Giroux, Inc., and Janklow & Nesbit.

Excerpt from *American Me* by Beatrice Griffith. Copyright © 1947, 1948 by Beatrice Winston Griffith. Copyright © renewed 1976 by D. S. Thompson. Reprinted by permission of Houghton Mifflin Company.

Excerpt from "Return" from *Selected Poems of Robinson Jeffers* by Robinson Jeffers. Copyright 1935 and renewed © 1963 by Donnan Jeffers and Garth Jeffers. Reprinted by permission of Random House, Inc.

Excerpt from *On the Road* by Jack Kerouac. Copyright © 1955, 1957 by Jack Kerouac; renewed © 1983 by Stella Kerouac, renewed © 1985 by Stella Kerouac and Jan Kerouac. Reprinted by permission of Viking Penguin, a division of Penguin Books USA Inc.

Photograph of Ansel Adams, 1953, by Dorothea Lange. Copyright © by The Oakland Museum of California. Reprinted by permission of The Oakland Museum.

Excerpt from *Assembling California* by John McPhee. Copyright © 1993 by John McPhee. Reprinted by permission of Farrar, Straus & Giroux, Inc., and Macfarlane Walter & Ross.

"Topographical" from *Big Sur and the Oranges of Hieronymus Bosch* by Henry Miller. Copyright © 1957 by New Directions Publishing Corp. Reprinted by permission of New Directions Publishing Corp.

Excerpt from "The Legend of Tu-tok-a-nu'-la" from *Legends of the Yosemite Miwok.* Copyright © by The Yosemite Association. Reprinted by permission of The Yosemite Association.

Excerpt from *John of the Mountains: The Unpublished Journals of John Muir,* edited by Linnie Marsh Wolfe. Copyright © 1938 by Wanda Muir Hanna. Copyright © renewed 1966 by John Muir Hanna and Ralph Eugene Wolfe. Reprinted by permission of Houghton Mifflin Company.

Excerpt from *Death Valley* by Nancy Newhall. Copyright © 1954 by Nancy Newhall. Reprinted by permission of Museum Graphics, Stockton, California.

Excerpt from "Comment and Historical News" by John C. Parish from *Pacific Historical Review,* vol. 1, no. 1, pp. 135–36. Copyright © by The Pacific Coast Branch, American Historical Association. Reprinted by permission of University of California Press.

Excerpt from *Exploring with Frémont: The Private Diaries of Charles Preuss, Cartographer for John C. Frémont on His First, Second, and Fourth Expeditions to the Far West* by Charles Preuss, translated and edited by Erwin G. and Elizabeth K. Gudda. Copyright © 1958. Reprinted by permission of the University of Oklahoma Press.

Excerpt from "Coda: The Wilderness Letter" from *The Sound of Mountain Water* by Wallace Stegner. Copyright © 1969 by Wallace Stegner. Reprinted by permission of Doubleday, a division of Bantam Doubleday Dell Publishing Group, Inc., Brandt & Brandt Literary Agents, Inc., and Page Stegner.

Excerpt from *Travels with Charley*
by John Steinbeck. Copyright
© 1961, 1962 by The Curtis
Publishing Co. Copyright © 1962
by John Steinbeck, renewed
© 1990 by Elaine Steinbeck,
Thom Steinbeck, and John
Steinbeck IV. Reprinted by per-
mission of Viking Penguin, a
division of Penguin Books USA,
Inc., and William Heinemann Ltd.

Excerpt from *West from Home:
Letters of Laura Ingalls Wilder,*
San Francisco 1915, edited by
Roger L. MacBride. Copyright
© 1974 by Roger Lea MacBride.
Reprinted by permission of
HarperCollins Publishers.

I WOULD LIKE TO THANK
the following individuals who
helped make this book possible:
Virginia Adams, Janet Bush,
Jessica Calzada, David Gardner,
Ann Gray, Kit Hinrichs and
Belle How of Pentagram, Patrick
Jablonski, Eric Lusignan of the
Ansel Adams Gallery, Antonis
Ricos, George Rise of the
Special Collections Department
at the University of Virginia
Library, Alan Ross, Merriam
Saunders, John Sexton, Jeffrey
Thomas, and the Trustees of the
Ansel Adams Publishing Rights
Trust: John Schaefer, David Vena
— and especially Bill Turnage.

A.G.S.

DESIGNED
by Pentagram

PRINTED
by Gardner Lithograph

BOUND
by Acme Bookbinding

TYPESET
in Futura Bitstream